# Growing Up
# UGLY

*Montta Harman*

# Growing Up
# UGLY

a story of finding beauty within

## Donetta Garman

TATE PUBLISHING & *Enterprises*

Published by Tate Publishing & Enterprises, LLC
127 E. Trade Center Terrace | Mustang, Oklahoma 73064 USA
1.888.361.9473 | www.tatepublishing.com

Tate Publishing is committed to excellence in the publishing industry. The company reflects the philosophy established by the founders, based on Psalm 68:11,
*"The Lord gave the word and great was the company of those who published it."*

Book design copyright © 2008 by Tate Publishing, LLC. All rights reserved.
*Cover design by Elizabeth A. Mason*
*Interior design by Steven Jeffrey*

Published in the United States of America

ISBN: 978-1-60462-754-1
1. Biography & Autobiography: Childhood Memoir/Personal Memoir/Women
2. Christian Living: Practical Life: Personal Growth/Women
08.01.02

# Dedication

Gar, you have shown me what it means to be loved in sickness and health, and in good times and bad.

You have taught me that the empty space in my life could not be filled by being loved by man, but by loving God.

You are my hero.

# Acknowledgements

I would like to thank my brother and sisters for standing by me while we were growing up and in the present. I can hardly wait for our next croquet or badminton tournament.

I would also like to acknowledge my parents for teaching me how to work and how to play. I miss you both so much.

Sheridan and Jeremy, there are no words for the joys that you have brought into my life. You have taught me much more than I could ever teach you.

Jacquie and Gary, if I wouldn't have married your dad and had you in my life by marriage, I would have still chosen you as friends.

Special thanks to the many friends who have read *Growing Up Ugly* and heard me talk about "the book." Your patience and support means the world to me.

My gratitude goes to Tate Publishing for their help in getting my story from my heart into print.

I thank my husband, Gar, for his encouragement during the writing of this book. I would never have finished it without his constant support and his endless wisdom.

And finally, I thank God for the gifts we see and the gifts He gives that are hidden from our view and only revealed a little at a time. I pray that this book is a reflection of what our

Father in Heaven is capable of, and pray daily that I will be humble and give the glory to Him, as He blessed me with the story and the gift of telling it.

# Table of Contents

# Foreword

I met Donetta during my third year as a high school language arts teacher. In retrospect I can say that at that point in my career, I was probably as unsure about my ability to effectively teach writing as many of my students were about their ability to learn to write effectively. Donetta stands out in my memory as an exception to this shared sense of uncertainty. She had a way with words. She could capture the essence of a situation, setting, or character. For a period of three years, I can recall that I eagerly looked forward to being able to read what she had written.

In her book, *Growing Up Ugly*, Donetta offers us a chance to see her life and the lives of her family in a way that most of us can appreciate. She is a wonderful "storyteller" who leaves the reader at times convulsing with laughter and at other times caught up in the midst of great sorrow. Throughout the book, however, there is a sense of hope.

It's not my habit to start and finish a book in virtually one sitting, but with this one, I did. When I finished it, I was left with many feelings and thoughts. Perhaps, foremost among them was the idea that regardless of the tumultuous mixture of sadness and joy in life, there is always one constant. This is that, "God is good all the time, and all the time God is good."

When Donetta contacted me and asked me if I would consider writing a foreword for her book, I was both surprised and honored. It seems I had written a note in her yearbook indicating that I was certain she would write a book one day, and that I was eager to be one of the first to read it. I hope that you enjoy reading her book as much as I did. I thank her for writing it and for the opportunity to share my humble thoughts after reading it.

Robert W. Johnson

# Introduction

As a child my favorite fairy tale was "The Ugly Duckling." I would dream of the day when I would be the one winning beauty pageants, the day that no man would be able to resist me and that when I walked down the street, people looked at me in awe of my beauty. I fantasized about people loving me and standing in line to be my friend. I waited to become a swan.

In searching for that type of beauty, I found that beauty really *is* only skin deep, and that what really, truly matters is the person that we become within. While my path has been long and treacherous, and hopefully, the journey is far from over, I feel fortunate to finally be taking the right fork in the road. This is the story of growing up ugly in a world where outside beauty is often more important than what lies beneath the surface. It is a story of overcoming dysfunction, addiction and the descent into mental illness and it is a story of the soul and inner self, and the potential beauty in all of us.

Ugly is not only skin deep. Ugly is to the bone and to the soul. It includes prejudice, taking from others, anger, addiction and hate. How many times in my life have I been told, "Beauty is skin deep, but ugly is to the bone?"

These stories that I am sharing are not in any chronological order. They were random ideas that came to me, and once I

allowed those memories to burst forth like a fountain that had been capped for years, I could contain them no more.

I knew my story had to be told, but the catalyst for its birth came on One Fall Day.

# One Fall Day

It seemed to be a day like any other. It was a wonderful, crisp fall day signaling the end of summer and the beginning of a new season. Orange, red and gold leaves fluttered in the gentle breeze, and I commented to my husband, Gar, that this was almost a perfect day.

"Perfect," he teased me, "because you are getting to go to garage sales and flea markets all day!"

"Perfect," I answered, "because I am with you and I am feeling better."

Earlier in the week I had some eye tests, a neurological exam and a spinal tap because I was having headaches and my left eye had lost part of its field of vision. I worked at being physically fit and I tried to keep my weight at a healthy level. We ate right. What could it be?

"We need to get home," my husband was saying, and I was buying several boxes of dishes to use in the tea room that I owned, along with a gift shop and clothing boutique. "Yeah, yeah," I teased in return as he carried them to the car.

I stumbled as I got into the car and then a flash of light and an excruciating headache struck me all at once. I took aspirin and thought I just needed to rest. As I sat there and Gar started heading for home, something was not quite right. There was

the headache, and there was the dimness in my eye and then I began feeling like I wasn't really connected to what was going on. I looked over at Gar and was going to ask him to pull over, as my headache was so bad I felt sick, but when I tried to speak, all that came out of my mouth was garble. He turned the vehicle around and we started toward the hospital. When I tried to get out of the car my left arm and left leg would not work. My left side of my face was beginning to sag and my left eye drooped.

I was rushed into X-ray for a CT scan and the doctors and nurses were rushing around. I wanted to speak to them and I couldn't. I could see the fear on Gar's face and the concern of the medical staff. I vaguely remember my doctor telling me he was going to have me transported by ambulance to a hospital in Kansas City. They had a brain and stroke ward. I tried to answer, but I couldn't.

I braced myself for the pain from a bump here and a bump there as I swayed back and forth in the back of the ambulance. The young attendant was looking at me with pity and maybe I imagined it, but with disbelief. I was only forty-five years old. My blood pressure soared and the driver turned on his lights and sirens. As I was unloaded and wheeled through what seemed like a big garage and down halls, then onto an elevator and into a room, I tried to pray. Words would not come, and fear engulfed my very being. I was not only separated from everyone I knew, but felt as if I were separated from God.

I can't give an honest account of being in the hospital because I don't remember much of the real-life events. I recall visitors coming in and looking at me, trying to visit, trying to make sense of what had happened. I would try to talk for a while and then doze off or get sick from the pain in my head— that excruciating pain, which was only dulled by the shot the nurses would give me ... that unbelievable pain.

Drifting off to a place away from the pain I began to relive so many events in my life ... and this is part of that story. I had

the realization that we are all just a work in progress, made up of all our life events. Everything we do seems to be directed by something that has come before, every action or inaction proceeded by another time and another event. Every opportunity, every mistake and every story is connected by a cosmic thread where each and every day our lives hang in the balance. While I still don't condone many of things in my past, love and acceptance overshadow the gray area between right and wrong. Often I didn't make the judgment call of what was proper or virtuous and what was superfluous and wrong.

For me that connecting thread was family. Family included my older sister by two years, Geneva, my younger brother by two years, Eddie, and finally, my younger sister by ten years, Lorinda, or Rindy, as we called her. I was the middle child, and my nickname from a childhood incident was Doc.

Family shaped who I was, who I am, and who I am yet to be. Well, I guess you really won't understand all of that, unless I start from the beginning.

# Let's Start from the Beginning

*This is the story of my beginning.*

"My water broke two weeks before you were born," my Mom would start. "I didn't go to the doctor because I was young and didn't think much of it." Then she would continue the story in a serious voice. "When I went in for my regular check up, the doctor couldn't find a heartbeat. He said I would just have to carry the baby until I went into labor. A few days later, I went into labor and we assumed that you would not be alive. It was a very painful delivery, because it was a dry birth ... since they weren't concerned about hurting the fetus, they started using instruments to literally just dig you out of me. I have never been in so much pain in all my life. I must have passed out because when I came to, they brought me the ugliest baby I had ever seen." She would pause for effect.

"It was you," she would continue. "Your head was smashed and red and looked like a Kewpie doll. You were just over four pounds in weight, long and red. I held you then and I cried, because I knew no one would ever love you. I said to you, 'You

are so ugly that no one will ever love you, except me. I love you, honey, and I will always love you, bless your little heart.'

"We brought you home in a shoe box because we weren't ready for a new baby, since we didn't think you were coming home at all. I wanted to name you Faith, but since our last name is Smith, and I thought that sounded like a lisp. I was watching a circus a few days before and there was a circus elephant on there. Its name sounded like Donetta, so we chose that. That way you were kind of named after your uncle."

I always took that story to mean that I was born a survivor. And as you read my stories maybe you will think I am a survivor, too.

I have a friend who believes that before we are born we meet with spiritual guides and plot our lives so that we may learn the lessons that our souls are lacking. If that is what is true with me, then I must have been talking and not paying attention and standing in the wrong lines. For one thing, I am sure that I was supposed to be a blonde. Many a hairdresser has commented that I would look better as a blonde. They describe my hair as "mousy", "dishwater" and "bland." Maybe I should have been a couple inches shorter, because being tall, people expect you to be less timid, I think. Oh, there are a lot of things I sometimes think about! I may have been in the wrong line for lots of things.

And surely I would not have lived in fear for most of my life. Yet maybe, if indeed there are spiritual guides, I was to become brave hearted instead of being Afraid of Everything.

# Afraid of Everything

From the stories I have been told over the years, I was afraid of everything from the first day I arrived home. The only person I wanted to hold me for the most part was my mother. I cried if anyone else even tried. Accounts from my parents and grandparents say that this lasted clear past my toddler years. I was even more scared of strangers, and this lasted so long that often times when people came to visit, they thought there were only two other children in the home. I liked staying in my room and being alone. Often, my mother would recall, she even brought my bottle, and later my food, into my room and let me eat there.

This was most recently brought to my attention when I attended my Grandmother's funeral. One of my aunts greeted each of my siblings and then when one of my sisters pointed out me she said, "I'm sorry, honey, I don't remember you. I don't remember you at all!"

Because of the trauma during my birth, I had seizures, and I was on medication for many years. It did not completely eliminate the seizures and when I was frightened or when I was bumped my head, I held my breath and then I passed out. This made it difficult for someone who was afraid of almost everything.

"Donetta," my first grade teacher addressed me, "can you read the words on the chalk board for the class?" I was totally silent. I can still take myself back to that time. Fear gripped me and I struggled to make out the words on the board. My face felt hot, I felt that embarrassing sensation as I had the urge to wet myself. I stuttered and then my opportunity to impress the teacher was over.

After failing to speak up, I would play with my hair and twirl it around my fingers. At night I relived what I perceived as humiliation and I pulled out my hair. By the end of my first year in school, I was completely bald on one side of my head from pulling out my own hair. My mother took me to an aunt, a hairdresser, and she gave me some oil to rub on the bald half of my head. I wore a scarf for months.

Second grade was the same, and because my last name began with an "S", I sat toward the back of the room. I was afraid to speak up, afraid to read aloud in class, afraid to try to decipher the words on the board. If it hadn't been for my best friend, Diana, I would never have played with the other children on the playground because I was shy and come to find out, severely nearsighted. A preliminary test at school showed that I needed glasses.

My world changed after I got glasses. Still shy, I had trouble fitting in, but at least I could see the chalkboard and I begin to excel in class. The kids teased me about my "cat eye" glasses, and one boy said I was uglier than a four-eyed dog. I couldn't belong to the girls "clubs" because I wore glasses, and everyone had to match.

To make matters worse, the anti-seizure medicine I was on caused me to be severely constipated. My mother was obsessed with my regularity as it was, so this was always a challenge. She would pin a note on my red Buster Brown shirt that said, "Donetta took Ex-lax today, please excuse her to use the restroom." Of course this was the subject of much teasing and embarrassment from the older children, and when I could

finally read I would take the notes off of my shirt before I got to school.

Fear of almost everything is what ruled my life as a child. I never defended myself. I would wet my pants before I asked to use the restroom in class. I would walk home from school, putting an extra few blocks on my route, just to avoid bullies. Yet, surprisingly, I loved school. I loved the smell of the books and of Big Chief tablets, and a new box of crayons. I loved the whole new world that it opened. I wanted to learn everything. I wasn't allowed to have books at home or to write and draw, as I was already a "wallflower" according to my father, and I would never amount to anything, if I didn't get some fresh air.

Once when I was exploring, I found a treasure trove of books in the attic of our garage. I spent hours in that attic and read those old dusty books. There were books of fairy tales, Gregg's shorthand, science, physics, novels and history books.

My sister, Geneva, who was two grades ahead of me, was always the smartest one in her class. She was confident and didn't seem to be afraid of anything. I would observe her from afar and strive to be like her. She was pretty and had a sense of style and fashion about her. For our birthdays, which we celebrated together since they fell within a couple of days of each other, she would ask for something, and then both of us got it. I was afraid to even speak up and ask for a birthday gift. Plus, I never really knew of anything except books that I would have wanted. She was good at choosing, though.

We always got matching outfits, until she was in eighth grade. Then we still got some matching clothing, but she would tell me when I could wear mine and when I could not. One year we got white go-go boots, fishnet hose, a purple plaid skirt, and a pink cardigan sweater. Another year we got bright yellow and red plaid ponchos. I also remember a green plaid skirt with a reversible vest.

When I was in fourth grade, and still running three extra blocks to get home, (I could no longer walk the extra distance

because I got in trouble for being late), a high school boy started picking on Eddie when he was on his way home from school. Rather than take a long way home, he went and talked to my father about it and my dad had a conference with us about bullies. "You have to stick up for yourself. If you run, then they will just keep picking on you."

It was decided that afternoon that after school let out, Geneva would wait for us and walk us home.

If the high school bully came, we would "take care of it." As for me, I thought avoiding this whole situation would be best. We should just go around the block and not tell our parents. We should never look at the bully directly in the eye and by no means should we ever talk to the bully! Geneva would have none of that sissy talk! It just so happened it had started snowing that day, and school let out early. Geneva waited for us outside the school building, stood between the two of us and we started home.

Sure enough the bully started calling us names. Geneva instructed us to keep walking unless he did something other than just call us names. Then the bully knocked Eddie's books out of his hands and into the snow. I froze in place. He seemed very big. He had hair stubble on his face, dark-rimmed glasses and short curly hair. Geneva ordered him to stop, and he picked up a handful of snow and threw it at her. "Get him," she yelled at us. I have to say that if I was afraid of the bully, I was even more afraid of Geneva, as she usually got her way. We set down our books and started pummeling the bully with snow balls. Then my brother got a hand full of mud and flung it toward him and hit his French horn case he was carrying.

"You hit my new band instrument," he started saying. I just knew we should run, but General Geneva insisted that we stand our ground. She bent down, picked up more snow and mud, made it into a ball and hit his French horn case again. His face screwed into a grimace. I shut my eyes and readied myself to meet my maker, but then I heard an odd sound. I

opened one eye, and saw that the bully was rubbing clean snow on his instrument case, trying to clean it, and he was crying. Having an understanding of being bullied, I felt sorry for him, but Geneva told us to get on home.

That night we related to Dad what had happened. He tried not to act impressed, but I think he was proud of us. The bully's parents came over that night and before they could even get to the house, my Dad went out to meet them, closing the door behind him. The three of us watched as he talked to the parents of the bully and then we saw them shake hands.

That boy never bothered us again.

I can't say that ended any feelings of fear that I had, but I can say that I had a new admiration for Geneva. It is a glimpse as to what she is still like. Family comes first. She will fight for family with a vengeance, and she is always there when you need her.

I have always believed that we are all born with our own unique personality, and there are certain characteristics that we possess and always keep. Geneva has a sense of loyalty and family to this day.

My timidity often led me to try to please people. In hindsight I see that it was most often people who really didn't need to be pleased or even impressed. Yet being homely, shy and afraid leads us into some very bad situations. In this life, I have either ran for my life or acted with false bravado, both getting me into many difficulties.

# Hey There Ugly Girl

"Hey there, ugly girl," a neighbor boy was taunting me. "What are you looking at?"

"Nothin' I need to tell you about," I sassed back. I was in our backyard picking up rotten apples and sticks and discarding them as part of my chores.

The two neighbor boys were in our backyard, sitting on our picnic table, smoking, and our parents weren't home. I was in second grade at this time, and often my folks would leave me and my two siblings home while they went to run errands. The boys were in high school and when they saw my parents leave, often they would come over and just hang out.

The oldest boy, a senior in high school, grabbed my arm. "I want to see if your butt is as ugly as the rest of you," he said. "I'd like to know if you are really a girl or just an ugly little boy pretending to be a girl." As he emphasized the word ugly, screwing up his face and I tried to jerk away from him. "If you keep trying to get away, I'm going to have to see for myself if you are a little girl or not."

Even though I was only eight years old, I can remember feeling hot and red and afraid. I kept trying to get away, and about that time my parents drove up. The older boy shoved me to the ground and left through our back yard.

I tried to find a way to tell my parents how afraid I was, but I was too embarrassed to even bring it up, and I didn't want them to stop leaving us alone because it really made us feel important. Plus, I knew Geneva and Eddie would be mad if we didn't get to say home alone. When my parents left us, they always gave us special snacks, and we could watch cartoons after we got our chores done. We were sometimes even allowed to eat a bowl of cold cereal with milk, which was really a treat.

The next weekend, once again they left us with a list of chores and we were home alone. As I peered out the back door, I didn't notice anyone there, so I started picking up sticks and rotten apples again. Someone grabbed me from behind and it was the older of the two high school boys, again. My heart was racing and I tried to wriggle away.

"What's the matter, Skinny Bones?" he teased. "Where do you think you're going?"

His brother started toward us and said, "Just leave her alone, Dirk, let her go."

"No, Kenny, I can't just leave her alone. I've been wondering about this all week, and I have to see if this ugly little kid is really a girl. Surely God wouldn't make a little girl this ugly." With that he shoved me toward his brother and his brother caught me.

"Now you just hold her and I'll check out whether or not this is really a girl." He took my glasses off of me. I knew if they got broken, I would really be in trouble and I tried to get them from him. Dirk put the glasses on and asked his brother, "Do I look like Stupid with these glasses on? 'Cause that's how she looks and I was just wondering."

Kenny didn't answer, but he continued to hold me. Dirk started trying to unbutton the top button of my shorts and I tried to kick him. Of course the two of them could overpower me and he managed to get my shorts down. I remember the shorts—blue and white striped seersucker. I remember my panties; they were white with little purple flowers.

"She has on girl underwear, so she must *think* she is a girl," Dirk sneered. Then in one quick motion he pulled down my underwear. He tried to touch me, but I kept kicking my feet forward, so he picked up a stick and was trying to touch me with the stick.

Just then my parents drove up in the front of the house. The boys dropped me, threw my glasses toward me, and got ready to leave, but not before warning me, "If you ever tell anyone anything about this, I'll kill your parents and then I'll kill you."

A couple of days later, my Dad was in the backyard and asked who had been smoking back there. "You, I guess," was my answer.

"No, it wasn't me," he answered. "If you know who it is, then you need to tell me." In a rush of tears, I told him everything. His face turned red and his eyes were fiery and I thought he was mad at me. "Go on in the house," he yelled at me. I saw him head down the road to the boys' property.

I ran as fast as I could into the house. Later when my dad came in, I could hear him whispering to my mom. Subsequently they called me into the room. They told me, "Never mention this to anyone." I never did. My mom stayed in the room after my dad left and told me that I was the kind of kid that trouble just followed. Then she issued me a warning: "Most men are just like those boys," she said. "They have just one thing on their mind." I had no idea what that one thing was.

# Flowers

*Each time I opened my eyes for a few minutes, it seemed like there were more flowers in my hospital room. A bouquet of beautiful chrysanthemums arrived. As I drifted back to my reverie, I began to reminisce again.*

"Do you know what today is?" my dad was asking my brother and me. He didn't give us time to answer and said, "It is Decoration Day.

"Some people call it Memorial Day. We go up to the cemetery with Grandma and Grandpa, and we put flowers on the graves of family members that have died. I want you kids to take your bikes and go pick fresh flowers to take up to the graves. Then later, you two can go with Grandma and Grandpa on a camping trip"

"Where should we go get the flowers?" my brother asked.

"Any where there are flowers," Dad said. "Just don't get caught."

"If we go get the flowers, can we go to the cemetery with you?" Eddie inquired.

"That will be fine, but you'll have to ride in the back of the pick up."

It didn't get much better than this. Eddie and I had sneaked up to the cemetery on our bikes many times, and we thought

it was an exciting place to go, plus we loved riding in the back of the pick up. We would stand behind the cab with our eyes closed and let the wind rush toward our faces. Often we pretended that we were flying like superheroes or that we had been pushed off a cliff and turned into soaring eagles. There are joys that the modern, *safer* world is no longer allowed to enjoy. Riding in the back of a pick up on a crisp spring day might just be one of them!

As we were leaving the garage on our bikes Dad reminded us, "Don't get caught and if you do, don't say I sent you." He laughed.

Since Eddie and I liked to explore, we knew where there were a lot of flowers. I would have been afraid to do this on my own, but Eddie made me brave. We would leave the bicycles on the street and hide behind trees and bushes until we reached the gardens where the flowers were. Eddie would pick them and I would gently take them from him. Then we would go on to the next house. We did this for several times, until our bicycle baskets were full. We didn't take a lot of flowers from any one house, so as not to ruin the person's entire garden.

"You kids did a good job," my father complimented us.

At the cemetery we heard stories about our passed relatives and ancestors. *This was Uncle Noah, he invented the picture tube for the television, but he became mentally ill and never really got the credit he deserved. He died in the mental hospital. He was crazy.* And then, *This was your great uncle, he was a hobo. Grandpa Falk came from Germany… this one came on a covered wagon.*

Later in the day, Eddie and I would pack up a few belongings and go camping for the weekend with our grandparents. We drank coffee in the morning, but not too much because "it would stunt our growth and turn our knees black," according to Grandma, and then we explored the forests while Grandpa fished and Grandma stayed at camp. Decoration Day was definitely a happy childhood memory.

*I reached out from under the sheets and stroked the petal of one*

*of the flowers. It gave me hope and a little chuckle. I realized how wrong it was to steal the flowers for the graves and I knew I would have never had my own children do such a thing, and yet I have to admit, it is a happy memory. I can still sense the anticipation of the camping trip ahead, the excitement of sneaking in and out of gardens and I can still feel the dew from the grass soaking through my worn canvas shoes.*

# Drop City

I felt so pretty in my new Easter dress. It was a pink and white taffeta check dress that my mom had made for me. It had lots of fluffy under slips. My grandma had made a dress for Geneva. We were going to church for Easter Sunday, as we always went on Easter and sometimes on Christmas. Eddie was wearing the cutest little suit and bowtie and he had a crew cut, greased and sticking straight up. Our outfits matched. First pictures in our front yard, and then we went to pick up my very best friend in the world Diana and her sister, Mary, and their mother, Margie.

More pictures in their front yard. We got to church early so we had our picture taken in the lawn of the church. I was so proud of my ruffled slip and lace trimmed socks. I had the prettiest pair of patent leather shoes I had ever seen. They were actually hand-me-downs from a cousin, but after a coat of Vaseline, they shone like new!

Since we were to the church so early, our mothers decided we could go to Sunday school. As soon as it was over we went to find our mothers so we could sit with them at church. They had been talking and they had a surprise for us. They were taking us somewhere very different that would be even more educational than Easter Sunday at church. After much discussion,

they decided we would just wear our church clothes. They said if we went home to change clothes, and the men caught wind of what we were up to, we wouldn't get to go. It was all sounding very mysterious by now!

We started out of town and the "speech" started. Whenever we went out to eat, went to visit people's houses or generally went out in public we got the "speech." *Be polite; don't stare; speak when spoken to but don't talk too much; don't ask too many questions (I think this was particularly for my brother, as he seemed to ask about whatever was on his mind, like the time he asked the Native American where his tomahawk was); don't tell our dads where we were going.*

We really liked it when we went someplace that we couldn't tell our dads about. It was usually more exciting than regular places, and we felt pretty important to get to go some place secret.

After about a half hour drive, we came to the top of a hill. Looking down over the embankment were these colorful domed houses. We were told later that they were fashioned out of car hoods and doors and that is why they were so colorful. As we drove into the compound of geodesic domes, past a hand painted sign that read *Drop City* with a peace sign on it, children in nothing but their underwear or a diaper and tee shirt, started coming toward our car. "Don't stare," we were reminded. "Just act like you see this kind of thing everyday."

A man with no shirt, but with a painted leather vest and lots of chains and beads and tattoos, came to our car. He had dirty, torn jeans and no shoes. The vest he wore had peace signs, roses and the word "Love" painted all over it. My mom, being the spokesperson she was, said that we had come in peace (which we all kind of thought was a funny line) and wanted to see how the "other half" lived. "Groovy," the man said. "We are all about love."

My mom and Margie talked about whether we should go ahead with this and agreed it would be very enlightening for us

kids. My mom parked the car and we all got out, patent leather shoes and all.

Diana and I held hands as we all followed the long-haired guy who had greeted us into one of the largest domes. It had a dirt floor and a long table down the center. There were little rooms all around the edges of the dome with burlap sacks and tie-dyed fabric forming partitions. There were lots of children running around, and lots of couples sitting and holding hands, and some people sitting around and smoking and eating.

"The table is for our guests," our guide told us. "We prefer to sit on the earth, but we realize our guests are used to sitting at a table and chairs. Please, help yourself to our food." The flies were as thick as fleas on a mangy dog, and I was a little bit afraid to eat anything.

Some of the other people started coming over to visit us. One lady kept touching my shiny black shoes and in a far off voice kept saying what lovely shoes I had. Some of the others came over and touched my dress and many of them asked us questions about where we were from and what we liked to do. By now, my mom was in her element and began the questioning that we all knew was bound to come.

*Why did they all live together in a commune?* They believed in free love, marriage and commitment just ties people down. For example, their guide had five children that he knew of, and all by different women. *How did they decide where to sleep at night?* They just knew what was right for them at the time. *Why don't they work?* They had to concentrate on their spiritual lives and bringing peace to the world through positive thoughts. *Do the children go to school?* They teach them what they need to know.

I could go on and on because once she started she turned into a veritable Barbara Walters and found out all there was to know. After what seemed like a very long time and many stares, it was time for us to go. There were hugs all around and the strange people invited us back any time.

Well, I didn't tell my dad, but I couldn't keep the experience

to myself. My best friend Diana never mentioned our trip to Drop City again. After a few weeks, I told about our trip during Show and Tell, while Diana gave me furtive looks, trying to get me to sit down and shut up! The teacher of the class happened to be the wife of someone my dad worked with.

One evening my mother came into my room and scolded me for not keeping a secret, because my dad had chastised her about our trip. I wasn't in *that* much trouble though and it was definitely a very good presentation for Show and Tell.

# More Show and Tell

I have always fancied myself a storyteller, and my favorite part of school was Show and Tell. For some reason, my shyness and fear would dissipate when it was time for me to get in front of a crowd. It was hard not tell about something when my folks would say, "Don't tell." That meant it was going to be a really good story, and I couldn't contain myself most of the time.

One year, shortly after elk hunting season had ended, we picked up Diana's family, and we all decided to go for a Sunday drive. This usually turned into a four wheeling adventure and this particular Sunday was no different. There were four adults and five kids packed into our Jeep Waggoner when we came to the end of the National Forest land to a fence.

After quiet discussion the men decided to just cut the fence. This was so common for me, that I didn't really see anything wrong with it. After all, many times during turkey season, Dad and Grandpa had cut a fence, went in and killed turkeys and had Eddie and me sit in the back of the Jeep Wagoneer holding them out the back window. We were given instructions that if they yelled, it meant the law was coming and we should just drop them on the highway.

When we came back out of the forbidden property, they would fix the fence and like Dad explained, the land belonged

to God, not to man, just like wildlife belonged to God and not to man. It wasn't ten minutes into the drive past the fence that we spotted a big herd of elk. There was a huge bull elk leading the pack. My dad and Diana's dad, Junior, agreed, they had never seen such a big animal. Too bad it is past season, they both concurred.

"I have my gun in here, but *it is* past season," my dad was explaining as he got out his gun. "I'm just going to look through the scope." He handed the gun to Junior and let him look through the scope. I don't know who was looking through the scope at the time, but a loud *kaboom* sounded and the elk began to run.

"Get 'em!" all of us kids started yelling. "Get 'em!" We loaded up in the Jeep on top of each other, and they started through the pasture to get the elk. The bouncing made Diana sick and she starting gagging, and in between gags she asked them to pull over.

Once they stopped, I got out with her and I pounded on her back to make her regurgitate faster. "Hurry, Diana," her mother was yelling. "Just barf and get back in the Jeep."

Before she even had the door shut, the Jeep was moving again. As we came up along side the herd of elk, my Dad and Junior got out of the vehicle. A couple more shots from the rifle and the great animal fell. Now was the problem of getting him home and sneaking him by wildlife agents and getting him tagged. They told us kids to shut the doors. The two of them walked to front of the Jeep and talked with great animation.

It was decided that the families would go home and the men would go back up on the mountain and to get the elk and work out the details.

It was just *too good* of a story to not tell for Show and Tell. Again, Diana gave me *that* look, especially when I told about her being sick. Again, the teacher told her husband and her husband told my dad and my mom came into my room to get

after me. I knew I was in trouble, but I could tell mom knew it was just too hard to not tell a good story.

That's why I don't think she will care that I am telling my story now, even the *ugly* parts, because it's just too hard not tell.

# The Games Families Play Now

*"Try to pick up these things," a nurse was telling me. She was trying to get my hands to work and gave me some sponge items to practice picking up and then "play with."*

"Try to pick up the pine cones a little faster," my dad was telling me. To make extra money, each fall we would go into the forests, pick up pine cones and sell them to the forest service to reseed forests that had burned or been killed by insect infestation.

I seldom got to work beside my father as he usually sent me with Mom because he just didn't understand me. I couldn't walk across a creek on a log, especially carrying a burlap sack full of cones. I would have rather been reading, drawing or writing poetry than spending time out of doors.

So, since I was getting to work with Dad, I was trying as hard as I could. As we got to the end of this "catch" of cones he told me to go and find another area and to look for Balsam Fir or Douglas Fir cones, as that was what we were short on.

I wandered through the forest and found catches of both. I was so proud of myself. When I came back to tell him, he poured a bucket of pine needles and leaves on me. Then he told me to go get my brother, sister and Mom. I went to get them and he finished his Mountain Dew and set it on a stump. It was

time for a quick game of kick the can before we started loading up more pine cones.

I asked my younger sister once what she thought made us such a close family, in spite of the dysfunction, when we were growing up. She answered that we learned to work together and we learned to play together. I think this is the secret of success as to why we remained such a close family through thick and thin.

There were a lot of evenings when my dad would lead us through the entire neighborhood or town playing a game of follow the leader. Or he would make us all stilts out of two by four lumber and blocks of wood, and we would walk as a family to town on stilts. It didn't even surprise anyone when they came to visit and he would throw a water balloon in the house. Or at the dinner table if you said, "pass the jelly," for him to actually toss it, or the butter or the vegetables.

Countless times he rigged firecrackers onto door handles to go off when the door was opened in order to frighten us. He would take the end of the garden hose and put in our pocket, ask us to hold it and then go turn on the water. You get the general idea. He was a prankster.

Moving all the of furniture out of the dining room and kitchen and having an impromptu dance as we learned to waltz, polka and jitterbug, was a common weekend event.

All games and events usually turned into tournaments. We didn't just play a game of badminton or basketball. We had a tournament. Even board games and card games were turned into tournaments.

Yet his mischievous behavior had a dark side. One time Dad and I were going into to town for some supplies after we had been picking up pine cones. We had a partial load of cones in the back of our old pick up. When we came out of the hardware store, the truck had a flat tire.

After much swearing under his breath, and then unloading the cones to get to the spare, he commented that we didn't have

a jack. I said that maybe we could borrow one. "We'll just borrow this one," he said as he took a handyman jack from a shiny new pickup that was parked next to us. He changed our tire and threw the jack into our pickup.

"We should put that back," I said quietly. "That's stealing."

"That son-of-a-gun has more money that we do," he answered.

"But that's wrong," I tried to reason.

"Doc, when you're trying to read those books you like so well, have you ever read the story of Robin Hood? Well, that is what I am doing. I'm taking from the rich and giving to the poor, which is us."

We had been taught that whatever our parents did was the right thing, but deep in my gut, I knew that stealing was wrong.

Shortly after this incident, we were going through an old abandoned resort, still looking for pine cones, and Dad spotted an open door. He pulled over and we went inside one of the buildings. We were in a dormitory area and there were beds, dressers, bureaus and night stands. I heard my parents discussing that there were so many happy memories here. Mom mentioned that this was where she worked as a teenager and she danced with Lawrence Welk in the dance hall. They continued talking and the subject came to the ownership of the resort now. "… he's a millionaire," Mom's voice was quiet. "They will probably just burn all of this stuff."

A few days later, Dad came home and said, "Empty your stuff out of the boxes you've been using. You have new dressers."

# Somebody Needs Me

I was only ten years old when my baby sister, Lorinda (Rindy), was born. The excitement I felt could not be contained. The shiny new crib was in my bedroom, and soon I would have a new roommate!

I didn't have a clue as to what having a baby in my room would be about, but I was sure it would be fun and exciting. Anyway, it would be much better than having my older sister, Geneva, in my room, telling me what to do, looking over at me like I was crazy, all the time. Yes, it would be a grand time!

My mother's mental illness had just begun to surface during her pregnancy with Rindy. She had always loved babies and I'm sure she felt as if it might "fix" her somehow. We all had high hopes pinned on this little girl that we hadn't even met.

The day Mom announced she was pregnant, she had been shopping. She spread several new infant outfits out on the kitchen table and said to guess what might be happening. The previous two summers she and her best friend were enjoying a very successful painting business... too successful, in fact. They put their heads together and decided that they had to get out of the business. Both of them decided to go off of "the pill" and have a baby. Both were pregnant within a few weeks of each other, and the painting business had to go!

When Rindy arrived home they brought her to my room, and the minute that I held her, I knew that no one could possible love her more than I did. When she cried during the night, I would put on my pink fuzzy slippers that were sitting by my bed and pad over to her. I would gently pick her up, careful to support her very floppy head and would feed her a bottle that Mom had left for me. Then I would burp her and change her little diaper and sing her a lullaby like "Hush, Little Baby" or "Count Your Blessings." I felt so loved and so needed, and I basked in the responsibility that I had been given. I learned so much from that tiny little person.

As she grew, my two older siblings and I argued about who could take her for a walk, or play with her, or bathe her. Rindy had all the attention we could shower on her in one day! One time the three of us even refused to eat because as a two year old, Rindy didn't get her way.

Yet, even as the youngest and having her brother and sisters to love her so much, when I see old photos of Rindy, I can see the sadness that lurked just beyond the surface reflected in her eyes. It was that pain that I tried to erase by being silly, by buying her things with my own money, not realizing that there are some things that can't be laughed away or purchased. During this middle age of my life, I realize Rindy was one of the first people who didn't see me for how I looked, but for what was inside of me. Our relationship has remained strong even as we have become adults. When Mom told us she was having a baby, and that the baby would be placed in my room, there was no way I could know that my new roommate would be one of the best friends that I would ever have.

# Taking Notes

*"Things haven't seemed right with me for the past six to eight months," I was explaining to the specialist. "I am usually energetic and looked forward to getting up each morning and facing the day. But lately, the pain and clumsiness I was feeling had been slowing me down." I was finding it difficult to find the words to explain the physical problems that I was having.*

*"I decided to have everything checked out when my legs started feeling so heavy and I began with the headaches. I just don't seem right," I told the doctor.*

---

When ever things didn't seem right, I always started investigating. And things hadn't been right for some time. I would walk around a corner, or more like sneak around a corner, and see my mother crying. She seemed to go through the motions, but didn't smile or talk. She had a distant look on her face and a vacant look in her eyes.

Rindy had just turned a year old and was as cute as ever, but Mom didn't seem to have much to do with her. It seemed if all of us were just going through the motions. Dad seemed so preoccupied and I caught him furtively glancing at my mother when she wasn't looking. Geneva, Eddie and I were going to

school, doing our chores, and generally just keeping to ourselves. It was cold and the middle of winter, so maybe everyone was just ready for spring. In a few days it would be my birthday and a couple days later it would be Geneva's birthday. Geneva, being the fashion maven, asked for these beautiful light blue dresses with a navy blue smocked bodice for us. She reasoned she could wear hers for a junior high dance the school was having and I could wear mine for Easter. She would be thirteen, I would be eleven. We had even decided on our birthday meal we would request: spaghetti, green beans and red velvet cake.

Like I said though, things did not seem right. I started looking around corners, going through the medicine cabinet, looking under the seats of the couch, and even the heat registers. I looked behind the copper gelatin molds that hung in our kitchen and I found a bottle of Valium. I carefully replaced it and knew that my instincts were right. Something was going on.

I continued my investigation. Looking in the garage, in the utility room and finally coming to my mother's sewing box and sewing stool. Inside the stool was a long letter written in Mom's unmistakable writing. I carefully removed it and went outside to read it.

I would like to say I climbed one of our many apple trees and took the document with me to read, but I was afraid of heights without Eddie with me to encourage me, so I just sat on the cold winter ground and began to read. I wanted to hurry up and scan it, so that I could return it as soon as possible. What I had stumbled upon was no ordinary letter. Although it was several pages long, it soon became apparent that it was a suicide note written to our family.

My mother explained that she had been unhappy for a long time and that she didn't know how she could go on. It was written using a thesaurus, which I had found in the sewing stool as well, and the writing was not simple, but flamboyant and colorful. I could understand the basics of the letter, though,

and the point was Mom was not happy and she was contemplating committing suicide in the near future.

I sneaked in the back door and sneaked into the room where the sewing machine was and I replaced the incriminating document. I decided that I had to tell my father about this and about the pills. That night at the supper table, which is where every controversial conversation was held, my mother addressed the family.

"Your sister has been snooping around again," she began with an angry glance my way. "She found a copy of a novel that I started and thought that it was a suicide note. She found some Valium, which I take for my nerves. I had the prescription hidden so that one of you kids wouldn't find it and take it accidentally. Everything is fine. Dr. Larimer gave me the nerve pills because who wouldn't need nerve pills with four kids and husband," she laughed uneasily.

I didn't really buy this whole story, but it was obvious that the rest of the family did, so I didn't say anything. After dinner Mom grabbed my arm and pulled me into the utility room. Pushing me up against the cold washer she told me to never snoop in her things again.

Our birthday celebration came and went. Dad decided to make part of our garage into a recreation and play room and he let us help with the remodeling. In the evenings we would all go out and paint and fix things up. It was a great family project. Dad had bought mis-mixed paint at the hardware store, and we were painting the room in wide stripes. He paid a hippie from one of the communes around the area for a couple of his abstract paintings, so that the man could pay his electric bill and we hung those up.

Everyone was allowed to help. One night Mom said she would stay in the house and do some things, but we could all go out and work. Once when I went in to the house to get snacks, she was sitting and holding Rindy and singing to her. While that should have been comforting to me it gave me a

very uneasy feeling. They were sitting in a gold arm chair and mom had an afghan wrapped around them. The chair was not a rocking chair, but they were rocking back and forth in a steady rhythm.

I went outside with the snacks, but my stomach had butterflies and I felt a deep sense of fear and a feeling of impending doom. We heard a crash and looked up. Mom was at the outside door and had fallen against it. Dad ran to the door and started shaking her and asking her what was wrong. "I did it," she kept saying. "I'm so sorry … I did it."

Dad dragged her into the house and called the doctor. He told her that he was afraid his wife had overdosed on tranquilizers. The doctor said we needed to make her vomit and empty her stomach and to keep her awake—no matter what.

Dad asked if he should bring her into the emergency room and the doctor advised against it, as it would be part of her record and she would be committed to the state mental hospital.

One of the things that always made Mom almost gag was raw eggs, so he mixed up a cup of beaten raw eggs and took her outside in the cold. He was able to rouse her enough to get her to acknowledge the eggs and she did rid herself of some of the pills. There he put same afghan she had been using while she held Rindy earlier around her shoulders and they walked and walked and walked; Mom was able to vomit some more. Dad sent us in the house and told us to go to bed. I didn't sleep. I *couldn't* sleep. I blamed myself for finding the note and for having the feeling that something was wrong and for not being able to make Mom happy. I blamed myself for everything.

# Shaky Fits

"Mom," I was yelling the minute I came in the door. "Mom, where are you?" I called. I went into the living room and there she was on the couch. She was laying down, her body stiffened out and she was shaking all over as if in convulsions.

I called my grandparents and Grandpa came over to check things out. By the time he got there and I got back into the living room, Mom was sitting on the side of the couch. She acted as if everything was normal and when Grandpa arrived offered him a cup of coffee.

I heard them whispering about how I worried about everything and that they really needed to keep an eye on me. Of course, he didn't know about the recent suicide attempt, or about the note, or about the Valium or counselor.

"She doesn't fit in at school," I heard my mother explaining, "and she imagines all sorts of things. I was just taking an afternoon nap." Grandpa said something so low I couldn't hear it.

"… uh,hmmm…. that might be good. All the kids think she's different, well she's weird."

There was more soft discussion and then I made out something that my grandfather was saying and it broke my heart. "… she just seems to live in fear of something bad happening

and she's so homely. Grandma and I have tried, but she's just a hard kid to figure out…"

I was always under the impression that Grandpa thought I was special. He gave me the best back rubs and was one of the few adults who tried to talk to me about what I was learning in school and what I was drawing and writing.

Not long after this episode, I came home from school and once again, my mother was on the sofa having a "shaky fit." Rindy was just wandering around the house alone. Once again, I called my grandparents and this time my grandmother came over. When she arrived, Mom was still shaking and laying there and she called over my grandfather.

They talked to Dad about it and Dad called the doctor. The doctor felt Mom might be abusing the tranquilizers and drugs.

"I am worried about an overdose," I overheard my father telling the doctor on the telephone.

The doctor must have advised Dad to dole out the pills himself because each night at supper he would give her the medication. My Mom was cunning, though, and she started seeing several other doctors and they prescribed medicines as well. Soon, each day, she was lethargic and emotionless. For the most part, the shaky fits stopped, except for when she would not get her own way about something. She would get angry and belligerent and then it would all end with a shaky fit.

I still remember what my grandfather said about me. I was weird and homely. I made an effort to try harder to please other people. That was the least I could do, since they allowed me, *ugly me*, to breathe the same air that they breathed.

# A Miracle

*"Your daughter is very seriously ill... more so that any of could have imagined," said Doctor Clarke, with a grim look on his face. He described the disease to my parents, who stood there shocked and pale.*

*My mother had not slept for three nights and her sunken eyes stared over at the small fragile body of her daughter lying there limp and lifeless in the hospital bed. "I'm going over to our motel room to take a shower and freshen up a bit," Mom said. At this time Mom was slipping further and further into her mental illness and often to handle things, she would just "check out" for awhile.*

*"I'd rather you stay here," Dr. Clark advised. "You see, Lorinda has a very complex disease; it is almost always fatal."*

---

It all started on a cold winter's day. Snow and ice made the highways a hazard; consequently the roads were closed from our small remote town to the nearest hospital. Five-year-old Rindy was sick and had already been to the community clinic three times that week, without results. Dad decided it was time to take her to the hospital.

Rindy started out with symptoms that seemed to be the flu, but as her fever got higher and her strength began to fade, we

knew it was time to get another opinion. My parents located a car with snow tires, but it couldn't make it to our house, so my Dad called a friend with a front end loader. They bundled Rindy in several blankets and put her in the bucket of the loader. Mom and Dad climbed on the side step of the huge piece of machinery and they went to a waiting car on the highway.

The three of us older children stood at the door with tear-filled eyes and heavy hearts.

A few days later my father came home to take us to the hospital. When we got there we heard Rindy's screams piercing the hallway as the nurses tried time and again to insert a catheter.

Little did any one know that her kidneys had stopped functioning and that she had internal bleeding. Our weary family doctor finally admitted that this illness seemed to be out of his realm of knowledge.

My sister, brother and I were taken back home and each time the phone rang, we were afraid it would be tragic news. "We've all got to be strong," Geneva reminded us, time and again. She was the only one of us who had seen Rindy and she was visibly frightened. In fact Geneva suggested that we all pray. A sharp ring of the telephone interrupted our prayer and it was my father. It was a race to see who could get there first. I managed to grab it and spurt out a hello all at once.

"We're okay, hon, and we'll let you know what happens," it was Dad calling from the hospital in the city. My grandmother came to stay with us. She did her best to comfort and reassure us.

I prayed the best way that I knew how, and I asked forgiveness for the times I was so impatient with Rindy. I remember specifically thinking about when she kept pestering me to push her on the swing or build a snow man, or when she would get into bed with me and put her cold feet between my legs.

Dr. Clarke, the city doctor, said Rindy's body was in crisis and that we should all prepare for the worst. Yet slowly,

meticulously the miracle began. Rindy's cheeks, framed with her soft golden hair, began to get rosy and her eyes came to life. Her first words for weeks were spoken and the doctor's knew that she was starting to recover. "I have to go potty," she said.

Significantly, for one of the first times in my life, I felt that prayers could be answered.

# Wolfman Jack,
# Zane Grey and
# Great Grandpa

Geneva's room was a tiny little room at the front of the house that at one time was the den. It had been converted into a bedroom when my great grandfather had come to live with us for awhile.

Let me back up here and tell you about my great grandfather. He had been a newspaper man in our small town for years and was very affluent. Mom would tell us stories about how they had the first television set in town, and how when she asked for a quarter, she was always given a dollar. Great Grandpa raised her as his daughter alongside my uncle, although my uncle and mother were only ten months apart.

Mom's mother had died from complications of childbirth, and she was taken in by her grandparents. She always spoke so highly of them, but both of them were alcoholics and she suffered much humiliation and abuse at their hands. Nevertheless, rather than send Great Grandpa to a nursing home, they had him come live with us. He no longer drank, but was still a little on the cranky side.

I loved sneaking into his room and looking at all of his

books. He had a vast collection of different kinds of books and many Zane Grey books. I liked the smell of his room; it was like that of paper and ink that old books waft of.

One year, somewhere on one of his jobs, my Dad found us an old whirligig merry-go-round. He fixed it up for us and we spent hours playing on it. We devised a plan where one of us would ride the merry-go-round and someone else would sit in one of the apple trees and throw a hula hoop around the person going round on the whirligig. One day, my great grandfather saw us and lost his temper. He thought that Geneva was hurting me and he began to whip her with the hula hoop. A week later he was in a nursing home and a year and a half later he passed away. So Geneva got his room.

That year for Christmas, Geneva got a small little transistor radio. They were the newest gadget and we all thought it was very cool. Often during the day we wouldn't get any of the stations very clear, but at night we could get a few of them. I would sneak out of my room at night and go to her room. She would tune the radio to an Oklahoma station and we would listen to the sounds of a D.J. named Wolfman Jack. I felt very cool being able to lie in her bed and listen to her radio.

Sometimes when she was feeling especially generous, she would get out her flashlight and show me a long chain she was working on made from gum wrappers or show me her Barbie doll and Troll doll collections. Geneva always had beautiful long hair, and it was really a treat when she would let me brush it while we listened to her radio.

---

*A few months after I got out of the hospital, Geneva and I went on a cruise together. We shared a room and I couldn't help but wonder: Whatever happened to Wolfman Jack?*

# Cane Lessons

*"Mrs. Garman," I heard the nurse in a distant place talking to me and then gently shaking me. "Mrs. Garman," she repeated, "It is time for you to go to cane lessons so we can try to get you out of here." She put her arm behind me and began trying to help me out of bed and into the wheelchair that was waiting for me.*

*"Cane lessons?" I asked.*

*"Yes", she answered, "it is part of your physical therapy." My husband had stepped out to go to lunch, and a friend was in the visitor's area waiting to visit me. She offered to go with me. I was so sick and my head hurt so badly. On the way down the long hallways, more memories began flooding me.*

---

I was twelve years old and my grandfather had just come home from the hospital. He was sixty-five years old and recovering from a heart attack. He leaned on his old wooden cane and was trying to straighten out the garden hose. Grandma came out and told him not to over do. He dropped the hose and walked morosely to the house.

My father was packing up our camper for one of our late summer camping trips and Grandpa stood looking over at him with a far away look in his eyes.

Fast forward a few days. "It's sad that Grandpa couldn't come on our trip," Geneva was saying.

"He can't come up to this altitude," Dad explained. "And he can't fish because of the strain," he added. It wasn't five minutes later when we saw my Grandma and Grandpa in their old International Scout making their way up the winding, bumpy road to our campsite. As they pulled into our campsite, Grandpa had a look of determination on his face. Dad knew not to confront him. We all acted like it was perfectly fine that he had just driven a hundred miles and found us way up in the mountains. He took a couple of worms from the Prince Albert can that sat on the hood of the old Jeep Wagoneer we were using, and walked to the river. One at a time he tossed them into a deep blue pool and watched as the trout gobbled them up.

He stayed long enough to direct my brother and me on how to catch a few rainbows and brookie trout, and to get them fried over the fire in a cast iron skillet, along with fried potatoes. Grandpa walked to the river taking the old enamelware coffee pot and filling it with water. Coming back to camp he put a couple of handfuls of coffee into it and hung it on the tripod that my Dad had fashioned over the fire. We ate the fish and potatoes and finished the meal with a slice of watermelon and a cup of *cowboy coffee*. Not one of us commented on the oil in the fish and potatoes, or the caffeine in the coffee, or the altitude of the campsite. We just sat around the campfire and enjoyed the moment.

My mom started singing the campfire songs that we always sang, and after we sang "Catch a Falling Star," Grandpa said in a mellow voice that it was time for him to go home. Grandma handed him his cane and they walked arm in arm to the old Scout. We watched as they went down the four-wheel drive road to the bottom of the mountain.

A few days later we arrived back home. Grandpa came over on the first morning we were back and said, "I will live my life to the fullest or I won't live at all." No one ever argued with

Grandpa or questioned him in any way. He went home and that evening he had begun feeling bad. Dad and Grandma took him to the hospital. The next morning when my parents and grandmother came into our house, I knew that he was gone.

"Mrs. Garman," I was jolted from my reverie, "This cane will be one of the best friends you will have for awhile." I stared at the cast aluminum cane with three legs and remembered the words of my grandfather, "I will live my life to the fullest."

It was in that brief moment in time, I had a realization how precious life is and how quickly the life we know can be snatched away. Until this time, for forty-five years, I lived as if nothing like this would happen to me. I now understood that we are all fragile human beings and that *this* can happen to anyone, even me. I said a prayer for acceptance and for God to take away the vanity that would keep me from using this important tool.

Grandma and Grandpa married when my grandma was just thirteen years old. She could milk a cow, kill and pluck a chicken, fix a fence, heat up the old coal stove and cook a meal for the thrashing crew on a shoestring, but Grandma had never lived alone or handled day to day finances and responsibilities by herself. This being said, the solution to her being alone was to send me to stay with her for a while.

I think the idea was that it was supposed to help Grandma not to get so lonely, but in truth the benefit was mine. I felt special and needed and learned a great many things staying with my grandma. We slept in the same bed and in the mornings, she would get up and make a fire in the old coal stove to heat up the house. Then when the kitchen was warm, she would get me up. We would have coffee and look at the view of the mountains. Then Grandma would make me a bowl of Malt-O-Meal and toast with honey. To this day, this breakfast is a comfort to me, and I fix it often when I am uncertain about what the day might hold or the turn my life might take.

On Saturday nights we would fix a plate of food and go

into the living room and watch the *Ed Sullivan Show,* and on Sunday night we would watch the *Lawrence Welk Show.* After a couple of months of staying with Grandma, an uncle of mine started coming around to visit. I would hear them talking low after I went to bed at night, and I felt that soon there would be changes for all of us. I mentioned to my dad that I thought that Grandma and Uncle Ted were going to date and he became very angry and sent me to my room. "Never talk about your grandmother that way!" he scolded me.

Just a few months later, they were married. Grandma took me aside right before they married and explained that there is only one true love in a person's life, but when that person is gone, we still have to keep on living. There is no other choice sometimes, except to get up in the morning, put on the best face and put one foot in front of the other. She said we should try to live for others if we don't have it in us to live for ourselves, because that is what God intended for us. She said that while she would never love my Uncle Ted in the same way she loved Grandpa, he would be a good companion. As I packed my bags to move back home, I saw the old wooden cane in the corner, and thought of change in all of our lives that it symbolized.

*Today, that cane sits in a corner of one of the rooms of my house.*

# I Think You're Beautiful

The summer before my eighth grade year our lives changed forever. Dad had been employed with the same electric company forever it seemed, and the employees went on strike when the company did not renew their contract. What was supposed to be just a few months strike turned out to last more than four years! Without a formal education and unable to read because of dyslexia, Dad had trouble finding a job to support our family.

Mom was fully into her mental illness, an addiction to prescription drugs, and alcohol by this time. Dad was taking jobs away from home when he could find them, leaving us home with our mother. During this same time since Dad's mom remarried, we moved out of town to the old family farm.

Mom and I had a deal. I would fix her drinks and promise not to tell and I could have a drink, too. On one particular day, I had fixed her several drinks and had one myself and she decided we should go shopping at a town that was sixteen miles away. That was great with me because I never got her just to myself. I didn't find out until later, she was actually going there to stock up on Jim Beam and vodka because she didn't like how the owner of the liquor store in town looked at her when she bought her booze there.

On the way there she kept swerving all over the road. I soon realized that this trip with just the two of us was going to be a mistake. I kept grabbing the wheel and correcting us. I saw that we were headed to a concrete bridge. I was a kid, and I thought I would just let us hit the bridge and we would stop and this nightmare of a ride would be over. We hit the bridge going about sixty miles an hour. We didn't just stop; we bounced off of the bridge and hit another car. The other car rolled down an embankment while we spun around on the bridge, hitting it several more times. The passengers in the other car were seriously hurt. One of them was able to get out and before the police and ambulance arrived, came to our car.

Mom, by now was out of our car and on the highway. She staggered over to him and starting using curse words against him, telling him that he had almost killed *her* daughter. He pushed her and called her a drunk and as they argued, help finally arrived. I had hit my head on the dash board, and broken my glasses and cut my nose. A policeman had us get in the backseat of his car and we started to the police station. I remember Mom being very nervous and asking questions like, "If I had a one mixed drink before dinner last night, will that show up in my blood stream?"

He asked her once more if she had been drinking today, and she swore she hadn't been drinking and I kept our secret. I now know that of course they knew the truth, and I can remember it being in the paper that she had a ticket for driving under the influence. I recall the stares when we went into town and the whispers behind our backs.

From the police station, they were able to finally find my father at one of his jobs. We waited at the station for what seemed like a long time. Mom's head would droop to her chest and then she would jerk it upright. During one of the times when she was partly asleep and partly in a stupor, one of deputies offered me a Grap-ette. He also took my glasses and taped them together with black tape for me.

Dad finally arrived, and after talking in a muted voice with several of the men at the station, he went with them to see the car. I stayed at the police station waiting for them. Finally, we all three climbed into Dad's old pick up. The trip home was very quiet and when he questioned me, I kept "the secret."

Dad had to get back to work, so he loaded all of us up, Mom included, and took us to where he was working.

There was a dam being put in to form John Martin Reservoir in central Colorado, and Dad was running a jack hammer all day long. It was hot and muggy and we lived in tents and took baths in the creek that would later be dammed to form the reservoir.

One of the guys on Dad's crew started paying a lot of attention to me. He told me I was pretty and when I asked if I was as pretty as my older sister, Geneva, he said yes, even more pretty. I know it was naïve, but I thought he really meant it. Did you know I still didn't know about men and their private parts? I didn't even wear a bra yet.

My glasses, which had been broken during the car wreck, were still taped together at the nose with black electrical tape. I'm sure I was very *pretty*. The man and Mom would drink together, and he knew my parents, so he must be okay was my thinking. One evening, I was sitting down by the river and he brought down a bottle of whiskey. He gave me a drink and the warmth I felt from the drink and then from his touch, was like nothing I had experienced. I thought it was love.

After several nights of repeat episodes of this, somehow my father caught on. He took me aside and said that he was going to find a way to take me home. He said that he had never been so ashamed of anyone in his entire life and that he was sorry that I was his daughter. There was more after that, about disappointment, about disgrace. I went to the river, but the guy never came down. I somehow, in my ignorance, thought he would come down and comfort me and then go defend me.

When I went back up to the tent, Dad and Mom were having a drink with him and laughing and playing cards.

# The Daily News

"Kids!" my father was calling to my brother, Eddie, and me, "I have got you two a job."

That is how we found out that we would have a paper route. I was eleven years old and my brother was nine. The route covered our town, with a population of about six hundred people.

It is hard to believe that in a town of just six hundred people there is a good part of town and bad part of town, but back then, that is how people saw it. I was the girl, so I got the good part of town and Eddie got the other side of the tracks.

Since we had to get up at about 4:30 in the morning, Dad had us sleep out in a part of the garage he had converted to a recreation room for us. Eddie and I slept on a fold out sofa. Eddie had rigged up an old radio to an old record player, so that when the alarm went off, the record would start playing. Oddly enough it played the Partridge Family's "I Woke Up in Love this Morning." We would eat the snack we had packed the night before and get on our bikes, on which we had mounted baskets all the way around, and go across town to the filling station. A bus dropped off the papers earlier in the morning. We would roll the papers and put a rubber band around them. If it was raining, we would slip them into a long plastic sleeve.

Off we would go to deliver papers. Dad arranged this route

for us so that we would learn responsibility. I think that over the course of the two years we had the route, *he* learned a lot of responsibility! It seemed as if at least once a week there was a crisis. It might have been a flat tire, a broken basket, a mean dog, a wayward skunk or bats. That's right—skunks and bats were also a problem. I was a very fearful, cautious person, and when a skunk was sauntering across the road or bats were dipping down from the street lights, I would be terrified. My brother still likes to tell the stories about me lying on the sidewalk with a jacket over my head afraid of the bats that were circling the lights, or taking a three block detour around a skunk and making us finish late, getting both of us in trouble.

There was also a big black dog that would chase me on most days. If the crisis we had was big, like a flat tire or broken basket and lots of snow, then we would go back home and get Dad out of bed. He would reluctantly get in our 1959 Ford pick up and take us around on our routes. I have the fondest memories of riding on the sideboards of that old pick up and stuffing papers into mailboxes. If the house didn't have a mailbox, Eddie's job on those days was to toss the papers up on porches (he was a much better aim than I was). Shortly after we moved out of town, Dad cancelled our paper route. I think he was secretly, or maybe not so secretly, relieved.

I guess we have already established that I was afraid of everything. Yet, my playmate was Eddie who wasn't afraid of much. He wasn't afraid of climbing high in branches of the box elder trees, so we could spy on people. He wasn't afraid to sneak down to the river and "borrow" a row boat and ride it down the rapids, and he wasn't afraid of jumping off of roofs and out of trees when I had invented a contraption that could help us to fly.

Really, I think he just liked it that I played with him all the time. He jumped off of our garage, house and many trees, and luckily never really injured himself much because none of my inventions ever really helped him to fly.

One time I had made a parachute out of some plastic we had found in the attic of our garage and he agreed to jump out of one of our tree houses. He hit the ground hard and he didn't move. I ran into the house explaining to my mother that Eddie couldn't talk and he couldn't walk and he couldn't breathe. By the time we got out to the tree, he was coughing and catching his breath. That was the end of my inventing days.

We were raised in a time when after doing our chores, we would be sent out to play. We had to entertain ourselves. My mom never checked on us, and we just had to be back at a certain time. One of my favorite pass times was going through all of the neighbor's garbage and making crafts out of items they had discarded. Then Eddie and I would load either our wagon or our bikes and go door to door selling the items. We would take the money we had earned and start to the store, picking up pop bottles along the way. The money we got for pop bottles and selling my crafts would be spent on pop, candy and sometimes a few special groceries for home.

Not realizing that brothers and sisters couldn't marry, we promised each other that we would marry each other, so that we would never have to be apart.

Eddie and I remained close during our childhood and later in high school. Often times when my parents would be arguing, we would sneak into each others rooms and hug until it was over or give each other back rubs. Sometimes we would pray to a distant God for the insanity to stop, but I don't think that either of us believed He could do anything to help.

# Occupational Therapy

*"Lead with your heel, and use the cane to try to get your left foot (the one that was dragging) to come along with you," he instructed. "Walk one foot in front of the other, point your toes forward, like your Mom used to try to get you to walk; shoulders back... look proud."*

---

I remember having a job at a small café in town during the summer. I was fourteen years old by now and tall and awkward. I started out washing dishes and then moved up to being a waitress. I would get there early to peel potatoes, scrub floors and do prep work. Dorothy, the owner and operator, entertained me with stories of living in California and the elegant life she led. "Get the books," she would order me in the afternoon. "Put them on your head and walk across the room. Imagine yourself as a movie star, one foot in front of the other, point your toes forward and be proud to be so tall."

In the second summer that I worked for Dorothy, she said that she had some news. She had been diagnosed with breast cancer. She was going to cut back on the menu, put in a couple of pool tables, pinball machines, and start serving 3.2 beer so that she didn't have as much cooking to do. My job would be

to take orders and go to the kitchen and fix them. She would not be able to help much, so since I wasn't old enough to serve beer, I would have to have the customers get it from the cooler themselves.

After my employer's surgery, I would come in early and put ointment on her incisions and help her get cleaned up and dressed. For some reason, that seemed like the most normal thing in the world.

Considering that I was the only employee and fifteen years old at that, things went pretty well. Dorothy was only open on Wednesday through Saturday. It is surprising for me to look back and see what a great responsibility and a great opportunity working at the Fun-O-Rama was, though there were many times when I would have to call the City Police Department to come over and help me with a situation. I continued to work there on weekends the next year, until Dorothy passed away.

On Mondays and Tuesdays of that same summer, my friend and I cleaned houses for a few of the more well-to-do ladies in town. One of them lived with her daughter and was quite eccentric. She "entertained" men quite often, and we were really interested to see who the married and unmarried men were that would pay a visit to the two ladies. Another lady was a fortune teller, and often when she didn't have cash, so she would read our fortune instead of paying us.

# A Monster in the Room

*"When I was born, I was so ugly that the doctor slapped my mother! He turned me over and said, 'Oh, how cute, twins.' I have home movies of my parents leaving the hospital with a sack over their head. When I was older they tied a pork chop around my neck to make the dogs play with me. I was taking a bath and my own rubber duck bit me!"*

---

It was a comedy routine that I had done more than once, learning to laugh at myself on the outside, while secretly crying within. My popularity during those days came from being the class clown. I was given "mock" awards at the school assembly, on the last day of school before summer vacation for "Worst Joke Teller", "Funniest Clown" and "Funkiest Walk." All that craziness, all that acting, hid the sadness that lurked within. My three best friends walked away with awards like "Cutest Walk", "Nicest Hair" and "Most Likely to Get a Date."

I was fifteen years old. It was the last day of school of my freshman year. My friends had boys wanting to date them, following them around, and carrying their books. I had boys wanting me to play football with them, be one of the guys, catch water snakes and ride bikes. At fifteen I *still* did not wear

a bra and I hadn't gotten my period yet. My cat-eye shaped, pink framed glasses were literally as thick as Coke bottle bottoms and my tall, thin, frame was unusually awkward.

I was assessing myself in the full length mirror in the bathroom when my mother came in. Her slurred voice, thick with alcohol, told me the story I had heard time and time again, "Oh, honeeeeeey, when you were born you were so ugly. The nurses brought allllll four pounds of you into me and I started crying, because I knew that no one would ever love you except me. I'll allllllways love you. Things haven't changed much have they, honey?" She staggered out of the room, and I can remember sitting on the edge of my bed and thinking that I would have to stay with my mother forever because she was the only person that could really, truly, love me. I remember the fear of that realization because she was drinking and taking so many drugs. I also recall that part of me didn't really want to stay with her forever, and feeling very guilty about those feelings.

Actually, I had hoped to talk to Mom about getting to wear a bra and shaving my legs. Also, I had read about a new innovation in eyewear—contact lenses. Maybe without my glasses, I could be a little better looking. Now was not the time to ask, though, for she had passed out on the couch.

Dad would be home soon, and I needed to start on supper. Eddie, who was home now, had athletic clothing he needed laundered for the next day, so I started that. Rindy was five and was working on a project of painting rocks at the table. My older sister, Geneva, was at rehearsal for an upcoming beauty pageant.

It's odd that there are days in our lives that stand out as stark as if they had just happened. This was one of those days. There wasn't any huge event, but I can still smell the sweet scent of vodka on my Mom's breath when I tried to wake her, so my Dad wouldn't know she had been drinking when he arrived home from work. I can hear the frightened accent in Rindy's voice when she asked, "Is Mom sick again?" and my answer of,

"She just has the flu again." I can still recall Eddie's frustrated hammering as he tried to fix his bike. John Denver crooned "Country Roads" on the stereo, and the hamburger frying on the stove sizzled like the atmosphere of our house, where a huge monster lives, but no one ever acknowledges his existence. I had never allowed myself to see the monster before, but there he was, ready to pounce. That's why I remember that day.

The door opened and Dad said, "How is your Mom feeling, Doc?"

"Fine," I answered cheerily.

When I glanced at Rindy, she looked at me in fear. By now Mom was propped in a chair at the table, trying to smoke a Winston cigarette.

"Dinner is ready," I said. We all gathered around the table, making nervous small talk, trying to get through the meal. As we were finishing our dinner, Geneva got home from her beauty pageant rehearsal. She still had on the professional makeup and she looked beautiful. Part of me was so jealous, and another part of me so proud. Mom nor Dad mentioned where she had been or what she had been doing, and I can still remember hurting for her. She was beautiful and she still didn't matter.

No one mattered that night, because of the monster in the room. As I lay in bed, with Rindy's feet stuck between my knees, and her little blonde head on my shoulder, I prayed, like I prayed every night, for no arguing from my parents, for my Mom to get well, that our house would never burn down or flood and that someday, I would be beautiful like my older sister. I prayed to a God that seemed so remote I was skeptical that he would even hear my prayers, and yet I longed to think that there was something in the vastness of my despair that would hear my prayers, if not answer them...at least hear them.

# One Potato, Two

*What was that smell? I struggled to come back to reality and as I looked over I saw a lunch tray at the side of my bed on the rolling cart. Adjusting my bed, I lifted the stainless steel cover and peered at the food: mashed potatoes, green beans and unidentified meat. Nearly retching, I quickly replaced the cover.*

*Mashed potatoes, she fell in the mashed potatoes...*

*The past once again became the present as I lay back down.*

---

There was a mother and daughter banquet at school. I planned on asking a friend of the family to go as my mother and Geneva could have our mother. But Geneva had already thought ahead, and she asked a lady who had befriended her, who happened to be the owner of the liquor store. I still wanted to take the friend of the family, Stella, but my mother's feelings would be hurt if at least one of her daughters didn't ask her.

The day of the banquet came and I knew we were in trouble when I went to see what mom was wearing. She had purple mini dress she borrowed from my sister and she was playing, "Harper Valley PTA" on the stereo. As I walked into the room the stereo blared, "... it's been reported you've been drinking and you're wearing your dresses way to high..."

For one thing, she would only wear a short dress if she was drinking because she always said she didn't like her knees, and for another, she talked about how she would like to tell the people at the school a few things like Jeannie C. Riley did on "Harper Valley PTA."

When we arrived at the school, Geneva left us to go find her "mother." In the hallway my mother kept talking to me under her breath about the "mother" Geneva had chosen being so self-righteous and what did she have to be so proud of. Then she excused herself to go to the restroom and when I tried to follow her to make sure she didn't drink anymore than she already had, she started to make a scene.

They started seating everyone for the banquet and I went ahead to find our places.

"How is Marilyn *doing*?" one of her best friends asked me.

"Oh she's good," I said nervously, and then added, "But she does have the flu." My Mom had a long case of the flu. It was the reason she didn't make it to most things at school, couldn't be a room mother and didn't work outside the home.

The meal was already being served when Mom made her entrance. She tripped slightly coming down the step to the cafeteria. She was finally seated beside me after much trouble getting into the cafeteria bench with her short dress on. I couldn't even eat my salad, and Geneva kept looking over at me, like I should do something.

When the main course was served it was roast beef, green beans and mashed potatoes. As I started to pick at my food, my stomach in knots, I heard a squishing noise. My Mom has passed out, her curly head, from a recent permanent gone bad, sticking out of her plate, with her face in her mashed potatoes.

"She has the flu," I protested. "She's had the flu for awhile now … she has the flu."

I got up and went to the kitchen to get a towel, but one of the cooks told me she would take care of it.

During the school year, to help out with finances at home,

Geneva and I worked in the school cafeteria and in return we were given a free lunch, so the cooks knew us well.

"She has the flu," I told the head cook.

"I know, sweetie," she answered. "It's been going around."

# I Heard It in the Wind

*Coming out of the fog of drugs and pain, I reached over to pull back the shades in the hospital room. The wind was blowing the fall leaves around. I prayed for clarity and to accept God's will. I thanked him for the days I had when I felt good and fell back on the bed with the whir of the wind blowing through my mind.*

---

Our household had been in a sense of excitement since Geneva said she was getting married. She had graduated from high school in May and the wedding was set for the end of July. I was actually excited for it because I was her maid of honor and my dress was so pretty. Rindy was the flower girl. There was talk of photos and flowers and receptions. It all seemed very much like a fairy tale to me. Geneva's husband-to-be, Jeff, would come over in the evening and play his guitar; he was handsome and I very much believed they would live happily ever after. This is just what the family needed was a celebration.

She dated the same guy forever and then Jeff, her fiancé, rode into town in his shiny new pick-up truck, and guitar in hand, swept her off of her feet. It was so romantic to a sixteen-year-old little sister!

Mom was not as excited. My Dad was still on strike from

the electrical company and working nights in a coal mine. A few days before the wedding, my mother had been drinking more than usual. Although she drank all the time, she tried to keep herself on an even keel, never crossing over that imaginary line, but that day she woke up from her nap in a strange mood. Eddie was spending the night with a friend, Geneva was with Jeff, and Rindy and I were home. Mom gave Rindy and me some money and told us to walk to town (which was a little over one mile) and buy ourselves supper. This was really a treat, but a nagging feeling told me not to go. Yet Mom insisted, so we headed on our way.

About an hour later, Rindy and I started back home. I was feeling scared for some reason and I told her to hurry. It was windy and I truly kept thinking I heard voices in the wind. We started running home and an ambulance passed us with its lights flashing. I picked up Rindy, who was six years old at this time and started running. A friend of my mother's had heard the police scanner and she picked us up. She was on her way to our house.

They were loading my mother into the ambulance and she was bloody from head to toe when we arrived. Officers and friends tried to restrain us and Rindy was hysterical. When the ambulance pulled away, another family friend took Rindy with her. The police officer that was left said he would go into the house with me and explain. Mom had slit her wrists in another suicide attempt. She had then gone through the house; there was blood all over the bathroom, the living room walls and all over in the kitchen. It seemed to be everywhere. She had panicked and changed her mind apparently and called for help and had spewed blood everywhere.

The officer questioned me and I can remember answering the questions robotically and methodically. Then I started to shake. He didn't even say anything when I got out a bottle of Jim Beam and poured both of us a drink. He took contact information for my father and sister and then he left me there.

I'm sure that I had some help, I don't really remember, but I do know that I cleaned up much of the blood that was left behind. Geneva came home somewhere in all of this. This happened just three days before the most important day of her life and even at my young, immature age, my heart broke for her. My heart broke for Rindy at a stranger's house, and for my brother at his friend's, and for my Dad who got the call at the mine and had to walk out in the cold, dark coal pit and come home to this, and for Mom who was living in hell.

The first time I ever I saw my Dad cry was when he got home. He had stopped by the hospital on his way home and had signed commitment papers again for another mental institution. The next day he took me with him to pick up the flowers for the wedding. Before we left he got the dress Mom was supposed to wear. After we picked up the flowers, we went to see Mom and he gave her the dress and her corsage. She seemed incoherent and her wrists were in huge casts, as she had cut all the way to the bones on both hands. When I glanced back at her, tears were streaming down her face.

It was at this moment in time I realized that the descent my mother was making farther and farther into the chasm of mental illness was not by choice. Her life, too, was spinning out of control.

The wedding went on as planned, but not as really planned. We all went through the motions and Geneva and Jeff moved out of state. The next day, my Dad got us up bright and early and took us to church. It was one of the only times I had been to church when it wasn't Easter or Christmas. It was a hard experience because we lived in a small town and everybody knew. Everybody knew and no one knew what to say. Yet, I believe that just being there planted a seed that there was a place to turn to that was bigger than us and there was something that could make sense of this.

# The Homecoming

Things were so different this time while Mom was away. Geneva was gone, Mom was still at the "nut hut" and Dad was still working nights. I was sixteen years old and I had the popularity that I had always dreamed of having. I also had the responsibilities of an adult. I was in charge of my younger brother and sister, keeping the house clean and doing laundry. I was also working part time.

I felt proud to be able to do it all, though. I had heard through the gossip mill that Dad told one of the men in his carpool that he didn't know what he would have done if I hadn't "stepped up to the plate" and taken over the family. Give me a compliment and I could leap tall buildings in a single bound!

I hated to admit that when then news came that my mother was going to be released from the hospital I was disappointed. I wished they would just keep her, and I felt so guilty for wishing that. But we were getting along fine. We didn't need her here with us.

When Mom arrived home she still had casts on both of her arms. She had had to have surgery to repair the nerves and tendons she had cut through. She barely had use of her fingers, and I loathed having to help her with getting dressed and her personal care. Even though I had the realization that she was

a sick person and not a bad person, I was so angry with her for coming home and messing up the rhythm of our lives.

For the first week she really tried to make an effort. She helped with the laundry, often using her mouth to help sort it and to fold it. She tried to keep a better attitude and we all started to settle in to a new routine. However, when the second week came, I came home from school and smelled alcohol on her breath and a rush of fear went through me. I began my search for her hidden stash of liquor and found it in a vinegar bottle, shampoo bottle and mouthwash bottle. I wrote nasty notes and put one on each of the bottles, instead of telling my father about my discoveries.

The next day when I got home late in the evening from school after attending a basketball game, she had found the notes and she was livid.

She met me at the door, butcher knife in hand, and threatened to kill me if I told Dad about her drinking. He was away at work, again. I tried to reason with her, but no matter what I said, she just got angrier and more aggressive with me. Luckily, Eddie was staying with a friend for the night, but Rindy was home and at six years old, she was scared.

It was late evening and after finally convincing my mom to put down the knife and that I wouldn't tell Dad about her drinking, she let us come in the house. I told Mom that Rindy and I were tired and that we were going to bed. I had Rindy come to my room and I put her in my bed. Then I went out to confront my mother. I knew deep down that I should let it go, but the frustration I felt wouldn't let me be still.

She called me names that I won't even repeat, and then she took her casts and starting breaking things in the house. I realized that I had pushed her too far and started to try to reason with her. When I got close to her she would hit me with the casts and kept trying to corner me so that she could beat me. When that didn't work she started trying to break out the picture window in the front of our house while shouting

obscenities. She kept threatening to kill me and said she hated me over and over. Again, she grabbed a butcher knife and kept trying to stab at me.

I slipped through the door and went to my room. I pushed chairs and a dresser against the doors. After opening a window, I broke out a screen so that Rindy and I could escape. By now, Mom was beating on the doors and stabbing the knife through the hollow core. Terror engulfed me and I grabbed Rindy and we climbed through the window. We lived just outside of town and with a rush of adrenaline I picked up Rindy and began to run into town. A car stopped and asked where we were going at that time of night. It was almost midnight by now.

I had this complete stranger drop us off at my friend Diana's house. When I got there, the lights were on and the door was open and Diana's mom, Margie was on the phone. She was on the phone with my mother.

"... I'll bring her right home ... uh, huh. ... yeah, uh, huh." Then she hung up the phone. She was on the phone with Mom, who told her that I was having a nightmare and just to bring us home. She drove us home and dropped us off in the driveway. Rather than go in the front door, we went back in through the bedroom window.

When my Dad got home at three in the morning, my Mom was still up and started defending herself to him. He had no idea what had been going on, except he could see broken glass and that the house was in disarray. He just wanted to get some rest, but she wouldn't let him go to bed.

I got out of bed, resting on the floor and put my ear to the space beneath my bedroom door. I could hear him trying to reason with her, and she was shouting, "It must be nice to be perfect. Everyone thinks you are perfect because you put up with me. There was only one perfect man and you must think you are him! At least you come down off the cross to eat and go to the bathroom. How does it feel to be perfect and have to be on a cross?"

Dad's voice was low and tired and finally I heard a door slam. Then I heard the car leaving the driveway. I didn't leave my room all night and in the morning when Rindy and I got up, we were the only two in the house.

I fixed our breakfast and got us both ready for school. We walked the two miles to school and acted like nothing had happened. I worked that night after school and had Rindy go with a friend. Eddie was staying all night with his friend, again. It was time for me to go home from work and my stomach churned. What would I find when I got home? *Nothing*. That is what I found at home. *Nothing at all*. No one was home, the lights weren't on. No notes. No messages. No parents and no confrontation.

A few days later we had a family therapy session in a padded cell at the mental hospital.

My mother's therapist said that there was something that Mom needed to tell us. In a voice that sounded as if she were telling us a story, she told us about her childhood. She talked about being abandoned as a baby and left with her alcoholic grandparents. She talked about physical and emotional punishment in vivid detail. While she told story after story, I sat there and wept. Rindy was sitting on my lap and I don't think she was fully grasping what was going on. Eddie had a far off look and sat away from the rest of us against one of the beige padded walls.

Next she said that she was going to talk to us about something that she had never even told our father, but that the therapists thought would help her to share.

"When I was twelve years old a carnival came to town. It was so exciting, because I had never been to a carnival." Her eyes lit up talking about it. Then they darkened as she continued her tale. "One of the carnies took a liking to me and he would let me ride his ride for free. He gave me money to go buy food and he went to some of the other booths and won prizes for me.

"I asked him what I owed him and he said to come back after the carnival closed for the night and he would tell me. I sneaked out of my house and went back there. He said, 'Why don't we go for a walk?' and I offered to show him where the hobos went to sleep when they got off of the train.

"He thought that would be fine and we so I took him under the bridge where the hobos stayed, but no one was there."

She turned pale and fell into silence. The therapist urged her to finish telling us the story. The hair on my arms was prickling and I remembered her warning of, "Men only want one thing."

"No one was there," she related, "no one."

Then she started to weep and through sobs related, "He raped me. He forced me to have sex with him. I was only twelve years old and he was so big and I was so little. I had never seen a...a man before. It tore me and I bled. He threw me down against a rock and I pretended to pass out." He just left me. When I went home I tried to clean myself up, but I couldn't get clean...I couldn't get clean."

We all sat there in stunned silence. Then the therapist asked us to leave the room a few minutes so that Dad and Mom could have a few moments. When we returned to the room, he asked each of us to come to Mom and tell her how we felt and then we each had to take a turn and say to our mom, "I believe you love me."

I crawled on my knees to her and took her hands and said, "I believe you love me." I can't remember if Eddie was in the room at this time. I just remember Rindy going up to her and climbing on to my Mom's lap and her little lips quivering and she said, "I believe you love me."

"Oh, baby," Mom said. "Say it again."

"I believe you love me."

"Again."

"I believe you love me."

"Again."

"I believe you love me."

"Again."

"I believe you love me."

"Again."

"I believe you love me," Rindy was shaking and sobbing, as she was much too young to know what was going on in this padded room, in this mental hospital, in this illusory state.

The therapist stepped in and pulled Rindy away from my mother. Mom kept holding on and Rindy had to be removed by force.

This incident, like so many in our lives, was never mentioned again.

Sometimes when I think of times like this, I think that I may start crying and I won't ever be able to stop. Sometimes deep in the dark of night, I fear the abyss that I could fall in, twirling and winding and rushing into the dark. It is endlessness. Life is so cruel. People are so cruel. Some of them fray the thread that ties all of us together.

When I picture all of the times we have sat in padded rooms as a family, and talked to different therapists, and when I remember all the dysfunctional things that have happened, I am afraid I will start laughing and never be able to stop. Will they put me in a straight jacket? Will they tie me to a bed? Will they run shocks of high voltage electricity through me and ask me to sit on the floor in a circle and talk about my feelings? Will I sit and string beads or lie in the fetal position in a padded cell? Who will hear *my* screams when I can't take it anymore?

# A Game of Catch

*The physical therapist came into my room and gently woke me up. "I would like to work on some coordination skills," she said.*

*After stretching, practicing walking in a line, using my cane for balance and trying to stand on my toes and heels, she decided to test my skills at playing catch. She would tap a balloon to me and I was supposed to react to tap the balloon back to her. Then she would toss me a ball and I was supposed to try to catch it, which was almost impossible at that time. It struck me so funny that I couldn't even accomplish this simple task.*

*After the therapist left, I dozed off from the exertion and remembered another game of catch.*

———————

"Just act like you're catching the ball," my mother scolded me. "It's not going to hurt you to make him happy and it will keep him quiet."

She had tried to commit suicide again, this time by prescription drug overdose, and was at the Colorado State Hospital for the mentally ill. I remember going to her ward and hearing the heavy steel door clang behind us. My father was in a conference with the doctor and my mother was left to visit us.

There were several types of patients in the visiting area. One of them was a tall man who was bald except for a few little white hairs sticking out the side of his head near his protruding ears. He had on a robe and slippers. When we first arrived

he was making a tossing gesture with his hand, looking up and making a catching motion. I spoke to him, and that must have indicated that I was up for a game of catch! He kept tossing the imaginary ball to me, and I was making him angry because I wasn't catching it or going to find it when I missed it.

"I made these for you," Mom said as she came over to me. There were all different kinds of beads on string, which she had made into a necklace. She seemed so spacey and preoccupied.

"Thank you. I love them," I tried to sound sincere. When we got home, I took the necklace to a rock cave on our property and put the beads in there. I said a prayer over them. I would have tried anything to help the insanity end.

Later, I learned that my mother had been having shock treatments and she was on heavy doses of medication. I was frightened and confused. I wondered who the person that was my mother really was.

# She Began Twirling in Grade School and Never Stopped

It was a home football game of my junior year and I was a baton twirler in the marching band. Since I was not the most coordinated person, and since I had such low self-confidence, I worked especially hard to be really good at this one thing. I had taken lessons in grade school. My father had enrolled me, thinking it would teach me coordination and grace.

At the end of my sophomore year, one of the seniors made a speech promoting me for an office in the student council. She listed my many achievements and activities; when she came to twirling she said that, "She started twirling in grade school and then she just kept on twirling!"

The night before the game, one of my friends was supposed to come over to the house so that we could practice our routine. When I got home from school, my mother was home. She had just been released from the mental hospital and I didn't realize she would be home. I hugged her hello and could smell alcohol on her breath. I told my friend to wait in the yard and I would be there in a minute. I confronted my mom about her drinking and she said she hadn't been drinking. I acted like I believed her and when she left the room, I looked in her purse. There

was a bottle of vodka in there. I took the bottle out and hid it and then went out to the yard to practice twirling.

"What do you think you're doing?" my mother screamed out the door.

"Twirling," I said hesitantly.

"Did you get in my purse?"

"No," I lied.

After she yelled about what a liar I was, and that I liked it when she was gone, and many other accusations, my friend got scared and left. I tried to explain to her, but she just wanted to leave, and to be honest I didn't want her to see what my life was really about either.

By the time I got ready to go into the house I heard the sound of an engine and saw that my Mom was going to drive. "If you didn't take anything out of my purrrrrrse," she slurred, "then I will have to go and buy something." I tried to stop her by getting in front of the car and she pressed on the gas and almost hit me. I fell back and I tried once more to stop her and she had turned the car around and was trying to run over me. I ran to a wooden fence and tried to go over it and she ran the car into the fence. Angrily, she got out of the car and started toward the house. She said she was going to bed.

I dislodged the car from the fence and parked it.

About an hour later, I went into her room to check on her and I could barely rouse her. I started to panic and found an empty pill bottle and realized that she had overdosed. I did not have my driver's license at the time, but loaded her in the car anyway. I went by my friend's house to see if she wanted to go with me, as if this was the most normal thing in the world. The hospital was sixteen miles away. I don't know how we made it there, but we did. The doctors pumped my mom's stomach, and knowing that she had just come home from the mental hospital, sent her back home with me. They gave her a prescription for Ant-abuse, to help her control her drinking. They warned her not to drink on the drug, as it would make her very sick.

I put her to bed and while I was waiting for Dad to get home, before I went to bed, I laid down beside my mom. I put my arms around her and started singing to her and she started sobbing. She told me about never having a real mother growing up and all she wanted was to be loved. I assured her that we all loved her. She told me about never feeling loved as a child and her own alcoholic parents and that she just couldn't live like normal people. She just wanted to die. "Tonight you can be my momma," she kept repeating as I held her. "Tonight you can be my momma; I never had a real momma." I continued to hold her until she went to sleep.

During the football game the next day, it was my turn to do an exhibition routine.

I had worked hard on it and it had been a challenge; my mother had been away in the psych ward and my father was working nights, and I was working part time and I had been in charge of keeping track of my younger brother and sister. I was also exhausted from the events of the night before.

As the band began to play, I stepped forward and began my routine. I'll never forget the song. It was the theme music to the movie *The Sting*. When I was about halfway through the routine, I looked out at the crowd and saw my mother staggering down the sideline. To my horror, she started onto the football field and toward me. "Doc," she started calling, "Doooooc, I need you to take me to the doctor. I neeeeeddd you to take me," she slurred. And what did I do? I just kept twirling... I just kept twirling. I never missed a beat and I never dropped my baton. Mom fell a few feet in front of me and the band played on. We made our formation and we marched off of the field.

A police officer came and then the ambulance crew with a stretcher. They took her off of the field and to the hospital. She ended up in the mental ward for several more months.

I realize now that is how I handled my life for so many years. I just kept on twirling, the band kept playing, and everything was fine.

# Make the Pain Go Away

*"My head hurts so much and when I try to sit up, I hear a rushing sound, like the wind,"* I was trying to explain to the nurses. *I just wanted the pain to go away.*

*The shot the nurse gave me, put me back to sleep, back to the tunnel that led to my past.*

---

It was my junior year of high school. I had a boyfriend that validated me, I was making straight A's, I had a part-time job that I loved and I had a drinking problem. When I would find my mother's hidden bottles, I had started sticking them between my mattress and my box spring. When things got a little tough, I would take a drink and it really did make things seem better. I was so much smarter than my mom; I wouldn't let it get the best of me.

I always had to have someone telling me that I was pretty, I was smart, I was fun and I was the best. My newest boyfriend did that, except for on this one day, when he knew I had been drinking again. He said I had to stop and I agreed to it. But the next day I drank again. Since it was vodka, I thought he wouldn't notice, but of course he did. He broke up with me. I took a package of Dramamine and told my brother I was going

to kill myself. Of course, I must not have meant it because I wouldn't have told him. "It is only a cry for help," the therapist would state later. That was profound on his part!

I started running away from my house, taking the pills as I went. My brother grabbed me and held me down and took the remainder of the pills. He literally dragged me to the house and to my waiting mother. She had been drinking and accused me of wanting attention.

"I do want attention," I screamed at her. "I just want to be loved. I just want to be heard."

When my father came home he was very angry with me and said he knew I would be "*Just like my mother.*" It was a small town, and by the time I got to school the next day, I was sure everyone knew what I had done. Most people knew that I was drinking during the day and that my home life was a wreck, and none of them seemed surprised. I kept liquor in my locker and in the toilet tank of the girl's locker room. We were "that family with the problems", so no one tried to intervene. I did start talking to the school counselor some, but I was cunning and was easily able to convince him that the report of my actions was greatly exaggerated.

This was another turning point in my life. The next week, my mother was back in the mental ward, Dad was putting in extra hours at work, and I was in charge of my brother and sister. I drank more, just more carefully. I continued to work part time at a local restaurant and lounge as a waitress, I changed my group of friends to a little wilder crowd, and I officially started my drinking career.

The summer of this year, I met a boy. He was a wild party boy, and very nice looking. His name was Paul. He really liked me and all the other girls were so jealous! He introduced me to recreational drugs. I was making really good money at work, I was growing out of my ugly stage, and the alcohol helped me to believe this even more. I had a new confidence that I had never had. I had all the time on my hands I could possibly want, as

long as I kept track of Rindy and Eddie. Paul really seemed to love me and I was sure this was the real thing. By the end of the summer we decided that we should get married.

Paul went to my father and asked him for my hand in marriage the beginning of my senior year in high school. My Dad said yes, and said we could even skip school the next day to go buy an engagement ring. We went to a town sixty miles away, bought a bottle of wine, and started shopping for rings. Since we were already there, we went by and saw my mom at the latest psych ward. We showed her my new ring. There wasn't much response. She thought she would be coming home in a few days.

I started my senior year with a new air about me. I still made straight A's; I was in volleyball, basketball, band, pep club, student council, drama club, forensics, business club and more. I felt unstoppable. As my relationship with Paul progressed I entered a whole new world. With just a word, he could get me into bars and clubs, where I was really too young to be. Even though I took speed and even tried LSD, I became concerned over *his* drug use. Sometimes when we would go on dates, we would stop off and meet people and give them packages. When I confronted him about it, he denied any wrongdoing. My own drinking and drug use progressed, and I was afraid to upset him too much. After all he *loved* me. He knew me, he could see me and he still loved me.

One of the teachers at school became concerned about me and he often called me into his classroom. He kept asking if I was sure that Paul was a good thing for me. He became a sounding board and I talked to him almost daily. One day he came over to my house. He was sitting in our kitchen and when I went past him, he pulled me to him and kissed me. Of all the times for this to happen, Dad walked in. He was just arriving from bringing my mother back home from yet another hospital stay. He threw the teacher out of the house. I was so puzzled about how this could happen, but my life was so full

of confusion, it didn't even seem out of the ordinary. It was just one more drama in a long line of drama being played out in my life.

When my father came back in the house he told me to pack up and leave. He said he didn't even know me anymore. I gladly went to my room and started packing my bags. The first place I went was to Paul's house. That ended abruptly when my dad called and told him what he had seen. No one gave me a chance to explain myself. Paul broke up with me and I was really alone. There wasn't any place in my small town that would let me rent. I was supposed to work that night, so I went in as if nothing had happened.

There was a new bartender and he was sympathetic to my situation. He fixed me a drink to calm my nerves. I called my parents and begged them to let me come home. I promised to be a better daughter. When I got off of work, I went home to a house filled with silence. The teacher was never mentioned again, though he constantly tried to get me alone at school. In all the years since that episode, we never talked about it.

The new bartender was at work the next night again. He was twelve years older than me, but I often felt so much older than I really was, I didn't consider this a factor. He asked if we could do something together sometime. I said yes and we dated for three weeks when he asked me to marry him and of course I said yes. But then that is a whole other story.

# Out of the Fire and Into the Frying Pan

As teenagers when we make decisions, we don't quite realize the impact that those decisions will make, not only our lives, but on the lives of those we love. I wanted to be loved. I was engaged several times in high school, always managing to run my suitors off with my neediness and temper. But one can only go to the barber shop and sit everyday, so long, without getting a haircut. The time came, my senior year in high school, when once again, I was asked to get married. Of course I said yes, and that decision would alter the course of my life and the lives of many of those I loved forever.

How little we know as a teenager. Only in middle age can I see clearly that time of my life; it is as if a light has illuminated and intensified every moment and every bit of knowledge. Then, I only knew of despair and desperation and wanting a change.

I felt as if a traditional wedding would be too much for my mother to handle, and my parents had said I had to graduate before they would give me their blessing. With those two criteria in mind, my fiancé and I decided that we would have a surprise wedding, on the night of my graduation. As valedictorian

of my class, I gave a speech about not forgetting the past, so that we don't repeat it, and when the ceremony was over, we told my parents to meet me at the church, we were getting married.

Did I love my husband to be? In some ways, I did. I certainly thought that I did. He *was* taking me away from the insanity that I was living in now. He didn't care if I drank and smoked. He said that he would take care of me, and I was so ready for that, because I felt as if I had been taking caring of others all of my life. The only people we invited were my parents, the minister and his wife, and a witness to stand up with my husband-to-be. The ceremony was quick. My mother sat on the front row of the church with a bottle of Jim Beam, sobbing. My Dad was in shock. We left town that night and only came back once to get the rest of my stuff for the first year.

The impact of that night on me, while much further reaching than I had imagined, was more obvious. The impact on those I loved has had to come to light over the years. My younger brother no longer had anyone to hold him when Mom was at home and she and Dad were either fighting or she was on a drunken rampage. My younger sister had no one to sleep with or to protect her. There were no hot meals, clean laundry, washed and styled hair or silly antics. My older sister felt slighted because she wasn't invited to the wedding and my husband-to-be had picked her ex-boyfriend to stand up with him. My mother was angry with me for wanting to leave. My father said that he felt like the "glue" that held the family together was gone. I had never even known they cared.

My new husband had quite a handful. He knew I drank, but did not know I was a budding alcoholic. He had never witnessed my insecurities, temper or jealousies. He could not make me feel secure enough or pretty enough or just "enough."

The marriage lasted for ten years. I can't truthfully say that they were all bad. There were some wonderful times, and had I been more mature and more whole it is possible that the

marriage could have worked. I brought out the worst in my husband and as my alcoholism and mental illness progressed, so did the demise of our marriage.

I had two children during this relationship. Motherhood does something to a person. I wanted to change because of them. I wanted to live a good life and be a good role model. I quit drinking right after my second child was born. My daughter was three years old.

Sobriety changed me and it changed my marriage. It was so hard to look inside myself and take the blame for what I had become. I had blamed my childhood, my ugliness, my husband, and society for the shambles that my life had become. Alcoholics Anonymous forced me to take the responsibility for what I was and what I did. This was news to me. Surely I couldn't help it if nobody understood me? I was just trying to survive, or so I thought.

I remember the day I finally made the decision to leave my marriage. We had a particularly bad argument the night before. The children, then five and eight huddled in the closet with a blanket over their heads to drown out the noise. I was stuck in traffic and was told it would be about an hour wait. It happened to be in front of a lawyer's office. I put the car in park and went in and made an appointment to start the paperwork for a divorce. As soon as I could leave I went straight to my AA sponsor's house and we talked and cried and talked some more. It was the first time in ten years that I had made a decision on my own and for me. It might have been the first time I had ever made a rational decision not based on fear.

The day of court I showed up by myself. My parents refrain of, "You've made your bed and now you'll have to sleep in it," held true. No one called and no one came to visit. Afterward, my parents said they knew I was a survivor and could handle it.

Years later when my mother was dying from complications of emphysema, she said that not being there for me was one of

her greatest regrets. She said that both she and my father had always thought of me as a survivor, and that it didn't seem like any big deal.

# A Chaplain's Prayer

*"Excuse me, ma'am," a gentle voice prodded me from my stupor. "Would you like to talk or to have a word of prayer?"*

*I rolled over to see a gentle looking man looking down at me. "I would very much like that," I said.*

*He took my hand and prayed for my healing and acceptance of God's will. I think I really did feel a little better after that.*

---

As I began to drift off, I remembered another prayer. "God, please help other people understand me. God, please show me a way to make more money. God, please make my mom sober, please make my dad love me, please...."

I prayed the same type of prayer all of the time. It was always about changing everyone else to fit my needs. This was my kind of religion. Now I had no one to blame but myself for the mess my life was in now. My mother was sober and attending AA meetings and helping others to attain the same serenity that she had found. My dad was attending Al-anon and was telling his story to anyone who would listen. I had left my husband, again. I had a two year old and I was six months pregnant. I was blaming everyone but myself for the mess that my life was in. Everything I thought would make me happy had happened.

My mother was sober, my dad and I were working on a good relationship. I had a great job, I had lost weight, and I had a family. Yet, while I was attending Al-anon meetings and talking the talk, I was secretly drinking.

One Sunday morning I heard something in the small single-wide trailer house where I was living with my two-year-old daughter. When I was finally able to get my bearings, I went into the kitchen to find the noise. My daughter was looking in the cupboards for food. "Mommy will feed you," I said. I opened the refrigerator and there was a ½ gallon bottle of vodka, some sour milk and a Mason jar full of leftover coffee from an Al-anon meeting a couple of nights before.

This was my *Ah-hah* moment. Things had to change or the reasons I had felt sorry for myself all my life would be the same reasons I would destroy my own daughter's life. I dropped to my knees and I prayed for a change; not in others, but in myself. I dressed my daughter up in a pretty pink dress and we went to one of the churches in town. That night, I went back home to my husband to try to make it work, one more time.

I drank two more times after that, and each time I drank until I was drunk, had a blackout, and did things I don't even remember; when I was told about them, I was abhorred. Right after I gave birth to my son, Jeremy, I was heading to yet another Al-anon meeting. It was right after I had been out drinking and blacked out. The two doors for the meetings were right beside each other. My mother was seated in the AA room. I started to go to Al-anon and instead I went into AA. The funny thing is no one was surprised except me.

My mother said to me, "You can get off of the alcoholic elevator at any time; you don't have to ride it clear to the basement."

At the beginning of the AA meeting the group recited the Serenity Prayer, "*God grant me the serenity to accept the things I cannot change, the courage to change the things I can and the wisdom to know the difference.*" Then everyone went around the

room and said their name and that they were an alcoholic, drug addict or both. When it came my turn and I said, "I'm Donetta, and I'm an alcoholic," it stands out as one of the most scary, yet successful moments of my life.

There have been so many stories in this book about events involving my mother, and yet she is the one person that taught me the most about life and second chances and God. Her childhood of abuse, abandonment, fear and hurting is so much worse than anything that I had to live through. I don't tell many of her stories because these are *her* stories. I never doubted her love of me. I never questioned her deepest motives. I only wondered how the person that she was really meant to be could be unleashed from the bonds that held her.

# Well Now I'm In AA

"Well now I'm in AA for a brand new way; I'm tired of misery. I'm learning to live one day at a time and I'm keeping good company," my mom sang the song she made up as we made our way to yet another AA convention.

My mother had a little over two years of sobriety, and I had just over six months in the program of Alcoholics Anonymous. We were going to save the world together. We all had a new lease on life and we wanted everyone to share in the joy of the AA and the recovery message. This convention was the Colorado State AA Convention, and both of my parents were the featured guest speakers at one of the open meetings.

During her high school years and early twenties, Mom was well-known for being a public speaker. She was nervous, but was definitely up for the task. As she told her story of the depths of hell and desolate desperation, what happened, and about how her life had changed, I sat and cried. I couldn't believe that this simple program was healing all of our lives.

My father wasn't used to public speaking. He had a reading disability and often when he tried to use big words, he got them confused (which made for many family jokes). Yet when he got up to speak, it was as if another person was up there giving the testimony of a man who never gave up, who loved

his wife as much as the first day they had met, and who took responsibility for his own part of the disease that wracked our family for so many years.

Shortly after this convention, my husband and I decided to move to Missouri with the company we both worked for. Our marriage was rocky and we thought that moving somewhere new and having to rely on just each other would make it stronger.

I was so afraid of leaving my family, making new friends and learning to live in a new place. The first thing I did when we got settled in was find an AA meeting. For me, walking into a room full of people that already knew me from that deepest place in my soul made all the difference in adjusting to a new place. My husband, too, found Al-anon meetings and began attending. However, it wasn't long until our marriage was in complete shambles.

I chose to stay in Missouri for awhile, make a little extra money, and then I planned to move back home. I started going around to schools and making presentations about teenage alcoholism. I told my story to anyone who would listen, and the more I told it, the busier I became trying to help others. I started talking to other practicing alcoholics and tried to get them to meetings. I attended meetings almost every night and went to conventions as often as I could. I went to jails and hospitals and to bars and homes at all hours of the night. I was leaving my children during the day to work, and during the night to attend meetings, and on the weekends to try to help others. One Saturday, as I was getting ready to go to yet another convention, my sponsor called me and said she needed to talk to me.

She had been diagnosed with cancer and there was nothing that they could do. She said she wanted to talk to me before it was too late. I thought she meant too late for her, but she meant too late for me. She said she admired all that I was trying to do, but that I had made AA my new addiction. She explained

that I needed to learn to live without my entire life being an AA meeting. She said, "Sometimes we find it easier to look at others people's lives, than to look at our own."

I felt slapped. Didn't I have an obligation to help others? I didn't go to the AA convention; instead I picked up my children from the babysitter and went home with them. She was right. I was not being any better of a parent than when I was drinking.

The next day, Sunday, I decided to take the children to church. A friend of mine had invited me several times and I decided maybe this would be good family time. I started attending church on a regular basis and even got baptized. I talked to a counselor and I still attended AA meetings, but only once or twice a week. For the first time in my life, I was able to *live* with myself.

I was lonely at times, but realized that God had a plan for my life and that he would reveal it to me when I was ready.

Although my mother did not stay sober, I believe that through the grace of God, I was able to look past that and live my own life. Instead of anger when I would hear of her trying to buy prescription drugs from people who were on pain medication, smoking marijuana or embarrassing herself in public, I felt sympathy and understanding. The embarrassment that I had lived with all those years was no longer mine to endure. I only regret she could not keep her grasp on the life she had within her reach during her sobriety. I can honestly say that I am thankful for everything. It has shaped me and molded me into who I am today. I feel so grateful for my life; all of it.

Ultimately, we are all responsible for our own actions. A wise person at an AA convention once said that we can have any feeling we want, it is how we act on those feelings that gets us in trouble. He said that we are not bad people trying to be good, but sick people trying to be well.

# A Ringing Phone

*"Mrs. Garman," someone was shaking me and a phone was ringing, "Mrs. Garman, do you want me to answer that?"*

*I'm not sure I answered, but before I knew it, she was putting the phone to my ear. It was my brother, Eddie.*

*"Doc, how ya doing?" he asked with concern.*

*"Not so good," I managed.*

*"What can I do?"*

*"Pray," one word answers didn't seem to hurt as much.*

*"If you don't mind, Doc, I'm going to pray for you now."*

*"K," I mumbled.*

*I don't remember all of the prayer, but I do remember him asking for strength, healing and courage for me to accept God's will. I lay there and sobbed uncontrollably. I was in so much pain. I was so sick that I couldn't even reach out to God for myself. I had tried to pray, but I couldn't even form a thought. I don't remember the phone being taken from me, but in a place far away from me, I could hear another phone in another time.*

---

It was early morning and we were just getting out of bed when the ringing phone sliced through the morning silence. My father was on the phone. I had a feeling of sinking dread

because my father had never actually called me. He would have my mom dial and talk first and then he would get on the line.

"Sweetheart," he began. This was going to be bad. He had never called me sweetheart in his entire life. "Sweetheart," he repeated, my heart was pounding in my chest. "I am making the call I thought I would never have to make." There was a long pause. I could hear him sobbing, another rarity.

"I went to the doctor yesterday and they finally figured out what was wrong. I have Lou Gehrig's disease." He briefly tried to explain the disease, but I was already familiar with it and can't even remember what he said. " … the way mine is has already progressed, they think I will have just under a year."

I began crying and handed the phone to Gar. This call came in December, and we began to make plans to go to there for Christmas for the first time in many years. I didn't have an aversion to going there for Christmas; we had always been so busy for the holidays owning a retail store that I just never had taken the time.

Christmas that year was one of the hardest, and yet one of the sweetest memories of my life. The next year my father's disease progressed rapidly and he was in a wheelchair, on oxygen and losing muscle mass within just a few months. I made it a point to get to Colorado to help take care of him as much as I could. I would dress him and give him baths, play cards and take him to ball games. I spent time with my mother, brother and sisters, like I never had. The fall before he passed away, I went out to stay with my parents for ten days. This was the first time in my life that I was in the house alone with my parents. At night Dad would request that I be the one to dress him for bed and to tuck him in. The fragile, humble, brave soul I discovered was the father I will always remember.

Toward the end of his life, he was no longer able to talk well at all. He could not spell, as he could not read, so he resorted to drawing pictures. He was in the hospital for what would be

the last time, and asked for paper. He drew a picture of what looked like E.T. from the movie, *E.T. the Extraterrestrial.*

"E.T.?" Rindy asked.

He nodded yes. He pointed his finger with the oxygen monitor on it up in the air and his mouth formed the words, *home.* His eyes filled with tears and he kept trying to say the word, *home.*

We knew that according to his living will, it was time to remove his life support. The doctor explained to my father and to the family what would happen. After a visit from the hospital chaplain and a brief prayer, the life support was removed from him. All of a sudden, the man who couldn't speak for weeks was talking! He talked about his past and where he was going. Then he would drift off to sleep. Seemingly, back from a journey, he would open his eyes and say things like, "I need my western boots. Dad and I am going riding tomorrow."

Next he woke up and said, "We are riding horses in to go fishing." At this particular time, a chaplain was in the room and said that the streams were clear and that you could catch a fish with every cast. My dad's eyes looked downward and he mumbled, "Geez, I hope not. That won't be very fun."

Waking up again, he rang the buzzer for the nurse. When the nurse came in, she asked what he needed and he said, "A miracle."

She answered him, "Mr. Smith, I think you have your miracle right here. Not everyone gets to have their whole family with them at this time."

While this was one of the longest days of my life, it was also bittersweet. Waking once more Dad said, "There are angels everywhere. Do you see them? Do you hear them? And look, there's Mr. Moore, and my Dad … they're waiting for me." Mr. Moore was our milk man and we all got a chuckle out of that. Shortly after that, he called each of us to his bedside and said that he loved us. Then as were all hovering around him and

trying not to cry, he said, "Now, get the hell out of here and let me go."

We decided to leave for a little bit and he died shortly after that in his sleep.

The healing I received the year of his illness and during his death has been invaluable. I was able to let go of past resentments, offering true forgiveness while gaining knowledge of how precious, tenuous and short life truly is. I gained a hope for endings with new beginnings and for a thread that never really breaks. I finally found the love and acceptance from my father that I had always longed for. The child still lurking in the corner of my heart knew that he had done the best that could.

# The Most Fun I Ever Had

When I was an adult, about thirty-seven years old, during the time my father was dying of complications from ALS (Lou Gehrig's) disease, the town I grew up in had a party for Dad's birthday, to celebrate his life while he was alive to hear it, rather than when he was gone. Townspeople took turns telling stories about him and the day, while laced in sadness, also had pleasantness to it, confirming how precious life really is.

Afterwards we all went back to my parents' home. Never missing an opportunity to play, my two sisters and my brother and I, along with our children, were down at the creek playing in the water. Pretty soon we heard a motor. Dad had managed to scoot himself from his wheelchair onto the four wheeler. He had taken bungee cords and strapped down his atrophied legs. Before we knew it, he came down to the creek and ran the four-wheeler into the water, splashing all of us.

One by one he took each of his children on the ride of their lives! When it was my turn, he took me up to the top of a mesa that overlooked the valley and the mountains. He turned off the four-wheeler at the highest point and talked of how beautiful it was. He explained that the colors were brighter and the feelings were more intense since he was dying. Still staring at

the expanse of beauty that lay before us, Dad asked me if I had any questions before he died.

If you had known my father, you would realize that this was not like him. We never talked about our feelings and I very seldom heard that he loved me. Taken aback and trying not to cry I did come up with a question. My question to my father was, "Why did you stay with Mom through all the bad times?" He turned back to look at me briefly and his eyes welled up with tears and then once again he gazed out at the view. He replied, "She's the most fun I ever had."

And that is what sums up why all of us grew up to be happy, productive people. Even in the worst of times our family played together. Before alcoholism and mental illness completely consumed Mom, I can remember a Halloween where we all went trick-or-treating. She invited her best friend and her children to go with us four kids. They dressed up like witches. First we would go up to the door and do our regular trick-or-treating, and then they would go up to the door and get on their knees, hold out a shot glass and yell, "Trick or Drink!"

Then we would go home and by then Dad would be home from work. He filled paper bags with fresh cow manure and put them in the back of the pick up. Then all of us kids would get in the back of the old '59 Ford and we would go trick-or-treating again. We would stop up the block and carry the sacks of cow patties to porches and my father would light the sacks. Then we would ring the doorbell and run to hide. When the people came out of the house, they stomped on the sacks.

Next we would drop my father off at the fire station. Mom drove the "getaway" car. Dad, an electrician, would wire the fire alarm so that it couldn't be shut off. Then he would get in the back of the truck with us kids and we would circle the block. While they were busy trying to shut off the alarm, we would get out and roll the fire truck (our small town only had one old truck) into the middle of the street. Next stop was the church, where the piano teacher's Volkswagen always sat; we would lift

it on to the church steps and then we went on to the city park where we stacked the park benches in a pyramid in the street.

I realize, as an adult, that would not be considered responsible parenting, and I am ashamed to hold those memories as fond, but we had to have some good memories to get us through the dark times.

Mom and I spent hours on the play equipment at the elementary school, with Mom swinging her feet and saying in her most earnest little girl voice, "Your mommy wears combat boots," "My mommy can beat up your mommy anytime!" and other comments as she drooled out the sides of her mouth. She was in every talent show that came along and did comedic public speaking at meetings of all kinds.

My mother would rather play a game of "kick the can" or "hide and seek" with the family than watch TV. She loved practical jokes and no one ever said, "Pass the jelly" to either her or my Dad since when they "passed" it, we lost several of our good dishes.

During her worst years when she spent several months out of each year in mental institutions, we would actually go there and "check" her out to go camping with us. For a time it would be like old times. Fishing, playing games, and singing "karaoke" into a marshmallow that had been pushed onto a stick, are all fond memories of these camping trips.

One particular trip, my father and brother had gone to bed and it was just us "girls." My mother took the marshmallow microphone and stood on the picnic table and began to sing, of all things, the old Ernest Tubb hit, "Sixteen Tons." In her low, sexy voice, at the end of each phrase, she threw off a piece of clothing and stripped down to her bra and underwear. Then my sisters and I took turns doing our strip act as she sang for us. Other times, she would purposely fall into a beaver dam where my Dad was fishing or sit in a running river and dare the rest of us to brave the cold, clear mountain rapids.

At least once during the two-week camping trips, we would

get a hotel room or a cabin to take a *real* shower. We would eat out, which was a real treat for us because we only ate out once or twice a year. Inevitably, we would go to a restaurant with a jukebox, and of course, being the country kids that we were, we would beg for a quarter to put in it and play a song. I knew what would happen, but always went along with it. My mom would take the quarter and ask, "What do you want to hear?" I always picked something that I knew she wouldn't know, but it didn't matter. She made up words to the song and belted it out.

"Dare me, just dare me," was a favorite phrase. Mom would take a dare. And Dad... Dad would look at her with such love. She didn't embarrass him at these times, and these are the times that helped to keep our family together. In later years, my mother suffered from emphysema. The last two years that she was dying, I would leave my home in Missouri and go to Colorado to stay with her whenever I could. After one especially bad coughing attack, I got her settled down, and then went to call my husband. When I came back into the room, she commented, "Did you call him to tell him to bring black?" During those times, she would check her oxygen level and then quip, "Yeah, today, I think you can buy green bananas, we should still have time to use them up."

In spite of her mental illness, often times my mother was filled with a wonderful sense of hope. Even after the worst nights when we got up in the morning, Mom and Dad would sit and have coffee, looking out of the big front window at the mountains. Mom often said, "Well, today is the first day of the rest of our lives." She passed that hope on to me. I can hardly wait to start each day and each new beginning.

During her funeral, several people asked to speak about her. Countless people stood up in the audience to talk about how she had started Alcoholics Anonymous in town. One person shared about how when she was blue and going through a bad time in her life, she would buy the ingredients to make smores,

pick up Mom, and go to a campground. The friends would sit around the fire, talk and eat the gooey treats. Several other people stood to talk about her sense of humor.

Right before Mom passed away at the age of sixty-one, I called her to see how she was doing. She could hardly catch her breath, but managed to tell me that she kept seeing my Dad out on the lawn on a horse. "If he thinks that I'm coming to heaven on a horse, he's crazy," she said. My mother was not a perfect mother, but then none of us are. She was a genuine person, who loved her family beyond measure. When I look back at her life, her illnesses, her suffering and then our mother-daughter relationship, I have to agree with my father, "She's the most fun I ever had."

# Can I Have This Dance?

The music was playing, the bar was open and hundreds of people were laughing and having fun. The difference was that every drink at the open bar was non-alcoholic and all those in attendance were either recovering alcoholics or family and friends of alcoholics. One of my friends was waiting for me at the door, along with her husband. Standing next to her was a cowboy with a big black hat, a western shirt and a red bandana around his neck.

I smiled at her and secretly chuckled about how this handsome stranger was dressed. As we made our way to a table, I accidentally brushed up against the cowboy's arm. *This is the one*, a small voice told me. *Surely not*, I remember thinking. *Surely, you wouldn't send me a cowboy with a red hanky around his neck.*

Nevertheless, when the music began to play, I asked him to dance. He said no. And I asked again, and he said no. Finally, with one song left, I asked and he said yes. As soon as the song was over, the dance ended and a group of us were going to have a small AA meeting. I invited the cowboy to join us and he said no.

"Who is that guy?" I asked my friend. "I don't think he liked me very much."

"You don't need to know," she chided me. "He's too old for you."

The next day was the final day of the convention and there was one final speaker before we went home. As he was speaking, I was particularly touched because he was talking about how people at his church said that alcoholism was not a disease because we *chose* to drink.

"I had no choice once alcoholism had me in its grip," he said. "I had no choice when I had to have a drink, and it was the difference between wanting a drink and needing a drink when there is no choice." His comment struck a chord and tears began to roll down my face. I felt a gentle touch on my cheek and looked up. The cowboy from the night before had reached across the table and wiped away my tear with his finger.

A few weeks later I was attending an AA meeting and there he was again. He casually walked up to me and put out his hand, "I'm Gar." We went for coffee afterwards and a few months later we were married.

It has not always been easy, but it has always been worth it. Learning to blend our families, raising my children and finding our own paths of staying sober were often challenging, but twenty years later I would have still asked him to dance.

# The Road Home

*"I am sending you home today," the doctor said.*

*I was excited, but apprehensive. My left foot was still dragging and I still had quite a headache. Even now I was slurring some of my words and my left eye drooped.*

———————————

But the road home is always sweet because the good memories are the ones we choose to keep. The love is what we choose to feel and the rest is just filler.

The next Sunday, my husband and I went to church. I wanted to personally thank everyone for all that they had done for me during the weeks I was in the hospital. The pastor made a call for anyone who wanted, to make their way to the altar for a special prayer. I limped to the altar and fell on my knees to thank God for second chances and for first chances. The time I had to reflect was also a time to heal and look deep into my soul.

I am so thankful for all the experiences of my life that have molded me into the person I am today. I am thankful that I "grew up ugly." I am so grateful for people who don't even know me who have lifted me up in prayer. If my friend is right and we do indeed choose our life path so that our soul may grow, then

I know for sure that I chose the family that was the best for me. And if we don't choose our family in some cosmic setting, I choose them now. I choose them to be my friends, my soul mates and my teachers.

I choose my first husband for the things that I could not have learned any other way. I choose him because he gave me two children who have taught me more than I have been able to teach them.

I choose my husband, Gar, because without him I would not have had the strength to find my own strength to face my demons and to realize my own beauty—that elusive beauty I had searched for, forever, that was within my grasp all along. Soon after my illness, Gar gave his life to Christ and has since become a pastor.

For a period of time in my Mom's life she was sober and well, and it was during that time I began attending AA meetings and stopped my drinking as well. I made the decision to live clean and sober, one day at a time. I had counseling and was able to deal with many of my past issues and mistakes. I was able to begin healing. When people hear parts of my story, they often wonder how I can talk so lovingly of my parents. They were *my* parents. They taught me everything I needed to know about life to make it through. They weren't perfect, but no one is. The only perfect parent we have is God the Father. I feel so relieved to believe that there is something out there bigger and more than me and this life. I feel so thankful that this is the real road home.